PHOTOGRAPHING JERUSALEM
THE IMAGE OF THE CITY
IN NINETEENTH CENTURY PHOTOGRAPHY

BY ISSAM NASSAR

EAST EUROPEAN MONOGRAPHS, BOULDER
DISTRIBUTED BY COLUMBIA UNIVERSITY PRESS, NEW YORK

1997

EAST EUROPEAN MONOGRAPHS, NO. CDLXXXII

TABLE OF CONTENTS

FORWARD

More than twenty years ago, a New England photography dealer, Mr. Frank Fink, introduced me, for the first time, to the nineteenth century photographs of the Middle East. From him, I bought several albums, and hundreds of loose photographs. This initial gathering became the kernel of my collection. Since then, the collection was augmented by several thousand photographs covering the Arabian Peninsula, the Levant, North Africa, Turkey, Iran, Cyprus, and Malta. Needless to say a large number of these photographs are of the Holy Land, because this particular area has strong and important historical and emotional ties to the entire Mediterranean region.

My particular interest in these photographs was purely historical and, to a lesser extent, esthetic. As a student of literary history of this area, I was fascinated by the depiction these photographs imparted to us about the Middle East in the nineteenth century in general. For example, I was fascinated by the photographs showing ways of drawing water from the ground, and also by photographs of water carriers. Every single photograph has a slight but telling difference. It is hoped that one day these photographs in my collection, some one hundred in number, will be studied for better knowledge of the relation between water and agriculture, on the one hand, and water and people, on the other, if such a knowledge is possible at all.

A second example is this huge mass of photographs covering the Holy Land in almost all its aspects. The photographs depicting its religions, peoples, social conditions, terrain, cities, towns, lakes, rivers, temples, churches, mosques, monuments, even streets and trees are, simply, countless. Every aspect is worthy of a special monograph.

It goes without saying that photographs are capable of telling more about the Middle East at that time than any written text. It is true that the changes in some societies are not extensive. Nevertheless, we do want to know about all the changes that may have taken place.

Photography is a direct result of the scientific advances which were made in the early part of the nineteenth century in optics and chemistry. At the same time, European colonization of the East was

well-advanced. In essence, the Middle East became a suzerainty for the big colonial powers of the West.

All early photographers were western, not only in terms of their place of origin, but also in terms of their attitudes, demeanors, mental frameworks, and anticipations. All these factors affected their photographs and colored them with their individualities and prejudices.

The grammar of photography is extensive. It covers not only the photographers and their backgrounds, the photographed objects and their backgrounds, but also the historical moment when the photographs were taken. All these elements interlace in a very complex mesh of photographic statements, clauses, and metaphors, all of which are fertile ground for researchers.

Serious studies of nineteenth century photographs of the Middle East are still in their infancy. With the exception of a few, they are not only scant and rudimentary, but also plagued with generalization and, to a lesser extent, ignorance. It is hoped that more serious and objective efforts will be made in this area in the near future, particularly by native researchers and scholars, since vast numbers of photographs are being collected by various institutions and individuals.

It is my belief that one such excellent study is that of Issam Nassar with particular emphasis on the holy city of Jerusalem.

A few artists, researches, and scholars have made use of my collection of photographs, but Issam Nassar is the first one to make an extensive use of the collection. His understanding, research, and interpretation, which he applied to the photographs of Palestine at his disposal deserve a rightful place in the historical scholarship of the area.

I was delighted when Issam asked me if he could use my photographic collection for his research. I am, indeed, happy to finally see Issam's work in print.

Mohammed B. Alwan
Tufts University
December 1996

ACKNOWLEDGMENTS

This book is the culmination of several years of work during which I had the support of many individuals, institutions, colleagues and friends. Their contribution, encouragement and support have been essential for its publication. It is a pleasure to thank each and everyone of them. If, as a result of the length of time the project took or of the numerous people that helped in different ways, I neglect to mention anyone, I apologize in advance.

This project would not have been possible without Adriana Ponce. Her patience, help, support and editing skills are what made this project see the light. To her, I dedicate this book. I am also immensely indebted to Dr. Mohammed B. Alwan, who put his photographic collection at my disposal for a number of years and kindly gave me permission to reproduce many of them. Were that not enough, he often offered special insight on a topic in which he is particularly knowledgeable.

I would also like to thank my academic advisor, Dr. Mohamad Tavakoli-Targhi, together with Dr. Lawrence McBride and Dr. John Freed, for their generous encouragement and advice. Other members of the faculty at Illinois State University were also very helpful in reviewing parts of my work and providing helpful suggestions: Dr. D. Kilgo of the College of Fine Arts helped me understand better questions relating to early photographic processes; my brother, Dr. Jamal Nassar often offered support and helpful suggestions.

I am also grateful for the opportunity I had to present portions of this work at the Middle East Studies Association meeting in Providence (1996) and at the First International Conference on the Christian Heritage of the Holy Land in Jerusalem (1994). In both cases I benefited from various suggestions from the audience.

Several other people were essential in providing contacts, in helping me locate various photographic collections, and in the process of buying and reproducing photographs. Among them, I would particularly like to thank George Hintlian of the Armenian Patriarchate in Jerusalem and Alia Arasoughly. The Swedish Christian Study Center in Jerusalem provided the initial impetus and financial support for the project. The History Department, the Graduate College, and the International House at Illinois State University also offered important financial support.

Special thanks go to Nick Ceh and to the person who took the interest to publish this book, Professor Stephen Fischer-Galati.

Finally, my appreciation and gratitude goes to my parents through whose eyes I saw another Jerusalem. To them, I also dedicate this book.

PREFACE

> With regards to many of these photographs, it was History which separated me from them. Is History not simply that time when we were not born? I could read my nonexistence in the clothes my mother had worn before I can remember her. There is a kind of stupefaction in seeing a familiar being dressed *differently*.
>
> Roland Barthes[*]

It was shortly after his mother's death that Roland Barthes went through some old photographs of hers in which she appeared as a young woman. The images that he saw were different from what he remembered. They were strange images of a familiar subject, i.e., images of his mother before he knew her, images from a time unknown to him. They were photographs of his mother in a world that he never knew.

The feeling I experienced while working on this book was not unlike Barthes' stupefaction. For the book is also about photographs of a very familiar subject from a time that I never knew. The subject is Jerusalem and the time is the nineteenth-century. Both the time and place are highly significant for historians of modern Palestine.

Jerusalem — a city that dates back to at least four thousand years ago — is a place that is considered holy by three great religions. The nineteenth-century was a time in which European colonial interest in Palestine was at its highest. It was also a century in which Jerusalem went through a process of transformation that changed not only the way it looked but its population's demographics and religious composition. At the turn of the nineteenth century, Jerusalem was a small provincial town — in the vast territories of the Ottoman Empire — which was inhabited by Muslim, Christian and Jewish Arabs and by a handful of European monks and missionaries. By the time it closed, it was a larger and expanded city which was the center of attention of the great European colonial powers. Photography did not always document the changes, but it often did reflect their effects.

[*] Roland Barthes, *Camera Lucida: Reflections on Photography*, trans. Richard Howard (New York: The Noonday Press, 1981), 64.

3

From a European perspective, photographers went to Jerusalem to unearth an unknown city which belonged to Europe's past, or so they thought. Ironically, in doing so, they preserved an image of the city which did not necessarily reflect the reality of its people at the time. Regardless of how vivid the memories of the Jerusalemites might have been, what was preserved in photographs for a large part of the world to see, unfortunately, outlived their memories. Nineteenth-century photography of Jerusalem is a dramatic example of the powerful effect of photographic representation.

This book begins by exploring briefly how Jews, Christians and Muslim imagined Jerusalem in past periods. Then, it considers a number of issues relevant to nineteenth-century representations of the city. But it is first and foremost a book about images. It illustrates how the city appeared through the view-finder of the camera at the time. Its goal is both to problematize the issue of photographic representation and to take the reader on a tour of nineteenth-century Jerusalem. In doing so, the book questions the presumed objectivity of photographs and displays what the city looked like at the time. For very often the photographs show both what the photographers intended to show and what they did not.

JERUSALEM OF THE HEAVENS

> The essence of place lies in the largely unselfcon-
> scious intentionality that defines places as profound
> centers of human existence. There is for virtually
> everyone a deep association with and consciousness
> of places... [that] seems to constitute a vital source of
> both individual and cultural identity.
>
> Edward Relph[1]

IMAGINING PLACES

Central to any discussion about *place* is an understanding that,
generally speaking, a place is a particular portion of the physical
world that is designated as such and thought of as detached from its
surroundings. It is, in essence, a *space*. However, the process by
which a place is created involves more than the mere designation of a
particular territory in a purely geographical manner. For whenever
a place is mentioned, a set of references or connotations that are
associated with it are usually invoked. Otherwise, such a location
would not signify anything else but its material nature. Designating a
location as a specific place is, in essence, assigning a meaning to it,
making it conceptually something other than what it physically is. To
use Bakhtin's terminology, it means transforming the physical loca-
tion into a *sign*.[2] In this process a certain level of arbitrariness is
involved, at least in relation to the demarcation of the borders of the
physical location.

For the purposes of this study, the physical boundaries of a
place are not as significant as the *idea* of place itself. It is place as an
idea, that we become conscious of when a place is mentioned.
Different places invoke in our minds different ideas, different
images and different feelings. This is a process that is social in
essence. Without a social setting and a context, a place has no mean-
ing. Places are significant inasmuch as they relate to human existence
and consciousness, inasmuch as they have been "socially and tempo-
rally *colonized* as sites of desire, power and weakness."[3] In this
context, it is place as knowledge — most relevant to a particular
community and contingent upon its existence as a community — that
concerns us the most. This is not to say that the production of
knowledge about a place is not connected with the physical place

5

itself, but rather that such knowledge is contingent upon particular experiences or interactions with the named site. Recalling the place, in turn, is but recalling the meanings, memories, images or tastes connected with that experience. In the process of writing history, places appear as "profound centers of human existence,"[4] as centers of interaction and socialization. In historical narratives locations are transformed into signs which designate certain historical events, connotations and imageries. To mention Rome is to bring to mind the glory of the Roman Empire. In this sense, places are signs of historical meanings and indicators of particular historical narratives. Germany for a historian of classical music is very different from the Germany of a historian of the Holocaust. For the former it is, perhaps, the home of Johann Sebastian Bach, for the later a site of genocide. In their narratives, Germany appears as something else, despite the sameness of its physical features and location on the map. In other words, as a place, it has more than one identity, each designating a particular experience in time. The city of Jerusalem presents a classic case for a location having a multiplicity of identities, each of which relevant only to a certain community.

This provincial city in a land torn by ancient and modern conflicts alike has occupied a prominent position among all cities for millennia. Jerusalem, a location that has been continuously inhabited for several thousand years, has a number of identities that become apparent only through experiences particular to certain communities and groups. In the words of one of its residents, Jerusalem is a city of mirrors.[5] It is as if each person in it, visitor and resident alike, were holding his own mirror, in which he sees only a reflection of his own past. Two religions, Judaism and Christianity, have their beginnings connected to it and a third one, Islam, has its tradition embedded in it. In recent years, Jerusalem has also occupied the center stage of the Israeli-Arab conflict. Its residents not only disagree on whose city it is, but even on what name it should be called. A number of "authoritative" historical narratives attribute different meanings to Jerusalem which connect. the city to one "imagined community" or another.

Understanding how a mere location was transformed into a multiplicity of signs that designate different meanings is essential in understanding how the physical Jerusalem was represented by European and American photographers in the nineteenth-century. Since the most obvious, and controversial, meaning associated with

Jerusalem is that of a sacred city, it is perhaps fitting that we start by briefly examining how it came to be considered a holy city by three Abrahamic religions: Judaism, Christianity and Islam.

THREE ABRAHAMIC RELIGIONS IMAGINE JERUSALEM

The first of the Abrahamic religions to assign a special meaning to Jerusalem was Judaism. The Jewish historical narrative takes King David's conquest of Jerusalem from the Jebusites and its establishment as the capital of his kingdom as its point of departure. The expansion and development of the city as the Israelite capital took place mostly during the reign of Solomon, the son and successor of David. The Hebrew Bible highlights Solomon's reign and his most significant achievement, the building of the Temple which "was declared to be the central place of Israelite worship."[6] A milestone in the Jewish narrative is the expulsion of the Jews from Jerusalem after its destruction by the Babylonians in 586 BCE. Another event which is highly significant in the Jewish narrative was the Roman ban on the entry of Jews to the city, a few decades after the destruction of the Temple of Herod around 70 CE. The devastation of the city and the exile of the Jews from it eventually led to the elevation of Jerusalem, in the Jewish traditions, to a position of prominence among all cities. The Babylonian Talmud best describes the significance of Jerusalem in the Jewish narrative; "ten measures of beauty were bestowed upon the world," it reads, "nine were taken by Jerusalem and one by the rest of the world" (Tractate Kuddushin 49:2).

The elevation of Jerusalem to such a prominent position in religious texts and the sense of commitment to remembering it not only preserved a tradition of venerating Jerusalem among Jews but also transformed the city, in the collective Jewish memory, into a spiritual location. Remembering Jerusalem became a "sacred obligation expressed through prayer."[7] The commitment to remember Jerusalem among Jewish exiles in Babylon, can best be illustrated through the words of Psalm 137:

> If I forget thee, O Jerusalem, let my right hand forget
> *her cunning*.
> If I do not remember thee, let my tongue cleave to the
> roof of my mouth;
> if I prefer not Jerusalem above my chief joy. (Psalms: 5-6)

Conceptualizing Jerusalem as a place to be remembered and as a messianic symbol led ultimately to the image of the Heavenly Jerusalem (*Yerushalaym shel ma'alah*). This new vision of Jerusalem was first constructed in the Babylonian captivity by the spiritual leaders of the community. Ezekiel, the Jewish prophet who lived through the experience of exile, was among the first to envision such an image of a new Jerusalem. He wrote of his vision that "the hand of the Lord" had brought him to Jerusalem where he saw the city and a new Temple in it and was told that: "the entire area of its enclosure [the Temple in Jerusalem] shall be most holy" (Ezekiel 43:12). Eventually, this new utopian Jerusalem, envisioned here by Ezekiel, evolved into a central theme within Judaism, reflected by the phrase "*L'shana Haba-ah Bi Yerushalaym*" (next year in Jerusalem), which has been continuously used by Jews to conclude two important sacred ceremonies, the *Yum Kippur* and Passover. In this context, it is interesting to examine why Ezekiel, together with other Jewish prophets, in the Babylonian exile foresaw such an image of Jerusalem. For after all, it was merely a small provincial city, even by the standards of that period.

It is important to emphasize that Jewish veneration of Jerusalem was a product of the experience of captivity. For although Jerusalem had been mentioned in earlier Jewish texts, it had never been referred to as a holy place, at least not in the same manner as it was after the exile. Therefore, it seems rather appropriate that the Jewish imagination of Jerusalem should be placed within the context of exilic experiences. For the construction of imaginary sites, of phantasms that resemble the original homelands, often tends to be the product of an experience of exile.

Writings of exiles in which the homelands are represented, redefined and recreated are widely available. In these accounts, the original place to which the exile wishes to return is described not how it actually is, but as a magnificent territory. The process of recreating the homeland not only involves memories of the glorious past but also incorporates dreams of a majestic return to the land, mixed with emotions, ideas and images that were acquired in exile through an experience not connected with the original homeland. Remembering past things — which is in essence a process of an imaginary re-creation of the place from which the exile has been barred — is important for exiles not only because it maintains their attachment to the place from which they were expelled but also

because it enables them to forget the difficulties that surround them. In this process in which remembrance serves as an escape from the oppressive present, the remembered site gets transformed into a symbol for the exiles' entire being. The places they leave become key in defining who they are. In his *A la recherche du temps perdu*, Proust explains how our existence is defined in relationship to a place that we have once known:

> The places we have known belong only to the little world of space on which we map them for our own convenience. None of them was ever more than a thin slice, held between the contiguous impressions that composed our life at that time; remembrance of a particular form is but regret for a particular moment; and houses, roads, avenues are as fugitive, alas, as the years.[8]

In a sense, places we once knew remain with us "ready to be summoned into consciousness and to unfold a profusion of meaning."[9]

The authors of the texts which celebrated and remembered Jerusalem was remembered, were not just any whose words had no influence on the other members of their community. The authors of these texts were prophets and rabbis; they were religious and political leaders of a community with a recorded history. They were individuals whose words had a profound influence on shaping the identity and memory of the community. As such, they were holders of the special responsibility of maintaining the unity of their community in exile, where such unity could easily be jeopardized should its members choose to integrate into the new environment. However, biblical accounts indicate that such integration would have not been very likely, for the Hebrews are portrayed as a captive population enslaved by their enemies, the Babylonians. While it is highly unlikely that assimilation was an issue then, there is no doubt that the feeling of otherness in the Hebrews' interaction with their Babylonian captures was a significant element in maintaining the unity of the community. For by now, the Hebrews were a community not only because they had a common ancestry or lineage, but also because they constituted the Other for the Babylonians. The continuation of Psalm 137, cited above, leaves no doubt of the extent of exiled Jewish resentment against the Babylonians.

> O daughter of Babylon, who art to be destroyed....
> Happy shall he be, that taketh and dasheth thy
> little ones against the stones.

The text of these verses reveals the existence of certain common goals, dreams and aspirations through which the exiles were able to preserve their sense of belonging to one community. In the words of Amos Elon, Psalm 137 "is not only a song of love and longing, but a savage song of vengeance as well."[10] The wish for the destruction of Babylon combined with the dream of return to a glorious past in Jerusalem played a central role in sustaining the sense of unity. Returning to Jerusalem — as expressed through the words, narratives and memories of the leaders of the community — became essential in maintaining the communal identity in the long term.

This is why when the Jewish prophet Ezekiel remembered Jerusalem fourteen years after he was exiled from it, what he envisioned was essentially a place he longed for, a glorious past that served in his consciousness as a reference for what he imagined himself to be. His account was not of what he had known fourteen years earlier, but of what he considered to be the future. For he wrote that he had been miraculously taken by the hand of the Lord to a utopian place which he thought was Jerusalem. This imaginary place was nothing like the Jerusalem he left, but more like the one he wished to see after his experience in exile. The irony is, however, that because Ezekiel's words were to have a real effect on the future topography of Jerusalem. For in his narrative, he told of how he was led to "the outer gate of the Sanctuary that faced east," where God told him that "this gate is to be kept shut, and is not to be opened" (Ezekiel 44:1-2). Regardless of what Ezekiel meant by this, the eastern gate (now the Golden Gate) in Jerusalem that leads to the Temple area (now al-Haram esh-shareef plateau) and that was sealed off by the early Muslim rulers "acquired a profound Messianic significance."[11] It was through this eastern gate of Jerusalem that, according to Christian tradition, Jesus entered the city a few days before he was crucified, and it is still there that, "faces turned towards the east, Jews, Christians, and Muslims await the coming of Ezekiel's prince as Mahdi or Messiah."[12] It is significant to notice how Ezekiel's vision influenced not only Judaism, but Christianity and Islam as well. In the "community of memories" that make up the Jewish tradition, the experience of exile — preserved in the writings of Ezekiel and other prophets — was mythologized. Henceforth, the way Jerusalem was envisioned in exile, i.e., as a place that leads to salvation, was consolidated as an essential part of the sacred knowl-

edge. Overtime, the city acquired a central location within the Jewish tradition as a sacred site, often referred to as *Jerusalem the Holy*. This name became so popular that it not only appeared regularly in religious texts, but was even engraved on coins. A coin that dates back to "the first Jewish revolt (AD 66-70)" against the Romans, on which the words "Jerusalem the Holy"[13] appear, illustrates this point. This sentiment of venerating Jerusalem continued to grow among the devout Jewish believers over the centuries. The following verses written by the eleventh-century Spanish Jewish poet Yehuda Halevi (1075-1141), best capture the Jewish devotion and longing for Jerusalem:

> Could I but kiss thy dust
> So would I fain expire.
> As sweet as honey then,
> my longing and desire.[14]

It was, perhaps, inevitable that Christianity — a religion which has its roots and history in the Jewish tradition — would eventually adopt a view of Jerusalem that is not very different from that of Judaism. After all, in its early stages, Christianity itself was merely a sect within Judaism. As such, it was only natural that Christianity would borrow, claim or inherit many Jewish ideas and rituals that would eventually be incorporated within its new tradition. And since the New Testament presented Jesus as fulfilling the Jewish prophecies about the Messiah, it was only logical that certain Jewish doctrines would be incorporated within Christianity especially if they served to support the idea that Jesus was the awaited Messiah. Nonetheless, despite the Jewish connection to Jerusalem and despite the fact that St. Matthew called it "Hagia Polis" (Holy City),[15] the city did not come to occupy the prominent position it occupies nowadays in the Christian world-view until the fourth century. And even then, when Christianity did develop its own position regarding the holiness of Jerusalem, the emphasis was altogether different from that of the older tradition of Judaism. The Christian narrative stressed the fact that Jerusalem was the place where Jesus lived, preached, died, and resurrected. As such, the city and its environs eventually came to be seen as the *Terra Sancta*, to which visitation was to be encouraged. The Christian position on Jerusalem was eventually developed on two distinct bases. The first was the connection with biblical history. The second one was the connection with the idea of pilgrimage to

Jerusalem as a metaphor for the journey to Heaven. While the first of these connections points to the city as the site were certain events occurred, the second one points to a concept relevant to salvation.

Although the connection of Jerusalem with New Testament events was not unknown to early Christians, it did not appear to have constituted a reason for their venerating the city. It is very possible that this attitude of disinterest was connected to the fact that the memory of Jerusalem as the place that betrayed Jesus was still fresh in the minds of the early followers of the faith. We are not aware of any authoritative historical accounts from the first three centuries of the Christian era that would indicate that Jerusalem held any special meaning to Christianity. After all, Jesus himself had described it as a city that murders the prophets and stones the messengers sent to her. According to the Gospel of Matthew, Jesus addressed the city with these words: *O Jerusalem, Jerusalem, thou that killest the prophets, and stonest them which are sent unto thee* (Matthew 23:37).

During the first two centuries of its history, Christianity had not yet developed into a unified coherent movement. Debates over religious beliefs, the nature of Christ, the role of the Church hierarchy, and even over which of the many books circulating at the time were to be recognized as canonical were the order of the day. It was not until the turn of the third century that this new faith was able to resolve many of its disputes and to emerge as a centralized "institution headed by a three-rank hierarchy of bishops, priests, and deacons, who understood themselves to be the guardians of the only *true faith.*"[16]

In this context, it took Christianity more than three hundred years to develop fully a distinctly Christian (as opposed to Jewish) position on Jerusalem. It was not until the Christianization of the Roman Empire in the early fourth century, that Jerusalem seems to have acquired a special place within the Christian world view. The writings of bishop Eusebius of Caesarea,[17] (260-339 AD) — the fourth century biographer of Constantine whose name is often associated with the founding of the Christian Holy Land — indicate an opposition to the idea of venerating Jerusalem.[18] While it can be argued that as the Bishop of Caesarea, he had a personal interest in maintaining Caesarea — rather than Jerusalem — as the center of Christian activity in Palestine, his position was, nonetheless, based on important theological reasons. For Jerusalem's exalted status, he argued, was a phenomenon of the past, when its primary function

had been to point forward to the coming of Christ and the foundation of the universal church. And since the events of the New Testament had already fulfilled this prophecy, according to Eusebius, Jerusalem no longer had any biblical significance.[19]

However, less than two decades after the death of Eusebius, a new view advocating an exalted status for Jerusalem was advanced by Cyril of Jerusalem (320-386), the author of *Catechetical Lectures*.[20] While Eusebius regarded the holiness of Jerusalem as an erroneous idea inherited from the Jewish tradition, Cyril openly advocated for the notion that Jerusalem was the Holy City, arguing that the Christian attachment to it was no different from that of the Jews. Cyril wrote that "Jews had recognized Jerusalem as a holy city and so too now did the Church."[21] It would appear that the Christian attitude towards Jerusalem, then, changed drastically during the fourth century. For from that time on, Jerusalem would continue to occupy a central location within Christian theology, imagination and historical narrative.

As a consequence of the prominent place it occupied in Christianity, Jerusalem became (in the centuries to follow) the center for Christian pilgrimage from all around the globe. Despite its being located far away from Europe, physically, spiritually and psychologically Jerusalem became its very center. Spanning the distance between the two places constituted, henceforth, a dream, a goal through which a sort of unity between the Christian and the heart of Christianity could be achieved. Reaching Jerusalem, to the Christian, was thus transformed into an act of grace and penitence. Because Jerusalem was the location of the most significant miracle, i.e., the resurrection of Christ, the journey to it was a metaphor for the journey to Heaven. It symbolized a cycle of rebirth and salvation which resembled the ascension of the soul to heaven. Eventually pilgrimage became a very important institution. According to D. R. Howard, it was "part of a complex of institutions" in late-medieval European culture "that included the Crusades, the cults of saints, indulgences, relics, and miracles."[22] And despite all the danger associated with the journey, pilgrims were eager to reach Jerusalem, so much so, that, in the words of one such pilgrim, they "cried out at every town and castle: 'Is that Jerusalem?' "[23] For to them, earthly Jerusalem was transformed into "a 'figure' or a symbol of the heavenly city 'like unto a stone most precious' which according to the Book of Revelation was to replace it at the end of time."[24]

According to Norman Cohn, this explains why "in the minds of simple folks the idea of the earthly Jerusalem became so confused with and transfused by that of the Heavenly Jerusalem that the Palestinian city seemed itself a miraculous realm, abounding both in spiritual and in material blessings."[25] Those who finally managed to complete the trip and walked down the same roads where Jesus had walked and stood on the same hill where he had been crucified reported experiencing a feeling of salvation and redemption. The fifteenth-century pilgrim, Friar Felix Fabri of Zurich, captured such feeling when he described the arrival of a group of pilgrims at the Church of the Holy Sepulcher:

> When all [the pilgrims] were gathered together in the court [of the Church] one of the Franciscans announced to them what that church was: the Church of the Holy Sepulcher itself, the chief aim of their pilgrimage, whose walls, none doubted, contained that very hill, that very tomb, where Christ had died, and from which Christ had risen.... The announcement caused frantic excitement. There were tears, groans, wailing, sighs, and sobs from the men; the women shrieked as though in labor.[26]

By the time of Fabri's arrival in Palestine, European pilgrimage was already declining and did not seem to have the same power to arouse European Christian imagination. The Muslim recovery of Jerusalem in 1187 together with the great schism in 1054 left the holy sites of Palestine in non-Catholic hands, thus possibly making it less common among Europeans to travel to Jerusalem. Furthermore, the sixteenth-century Protestant Reformation, which led to new ways of looking at the Bible and a redefinition of the responsibilities of the faithful, had a direct effect on European travel to Jerusalem. Pilgrimage was not seen by the new Protestant Christians in the same light. For it would appear that the act of preaching the Gospel through missionary work replaced pilgrimage as a way to attain salvation. European travelers did not cease to arrive on the shores of Palestine however. They continued to visit Jerusalem, only for the most part, their motives for traveling had changed.

The new spirit of adventure and discovery that swept Europe from the fourteenth century on motivated new types of travelers to journey to different parts of the world. Apart from the handful of pilgrims who continued to visit the holy sites, adventurous

Europeans keen on rediscovering new lands often visited Jerusalem on their way to other destinations. The new sense of adventure, curiosity and discovery was reflected in the emerging genre of travel writing that was becoming increasingly popular. A powerful example of this emerging spirit, the *Travels of Sir John Mandeville*, presumably completed in 1356,[27] continued to be regularly published and translated from its first printed version in 1499 until the early 1900s. In the book, Mandeville's fascination with and zeal towards Jerusalem, the Holy City, are as strong, perhaps, as those expressed by pilgrims such as Felix Fabri. He too described at length the routes to Jerusalem and the Holy City's shrines and marvels. But unlike Felix Fabri, Mandeville was no pilgrim. He was an adventurer whose trip to Jerusalem was part of a grand trip that took more than a decade to finish and in which he visited many other parts of the East. Although he expressed a sense of veneration for Jerusalem, his work reveals a departure from the earlier European attitudes towards the city. The urge to possess Jerusalem materially, as was expressed through the Crusades, was replaced by a claim to Jerusalem as a precious heritage for all of Christendom. Mandeville's facts about Jerusalem and the world however, were proven to be fantasies around the mid-nineteenth-century. Even the very existence of Sir John Mandeville has been questioned. It appears that the author of the book never left Europe and that his book was based on accounts and beliefs which were common in Europe and documented in other books.[28] The conspicuous correspondence and similarities between Mandeville's accounts and the accounts of those who had actually visited Palestine are striking. The places and shrines that Mandeville presumably had visited, had been the same as those regularly visited by pilgrims. The correspondence between Mandeville's fictitious and exotic Jerusalem and the actual city visited by Friar Felix suggests that a distinctly European view on Jerusalem, rather than a general Christian one, was already in existence. The similarities can be explained in light of the fact that the roots for the new European view on Jerusalem go back to European Christendom and its view of itself. The extent of this view can be felt in other areas of European knowledge. Take for example the world maps produced in Europe well into the sixteenth century. In these maps, Jerusalem was customarily placed at the exact center of the world. This phenomenon can be found even as late as the end of the sixteenth century. A map by Heinrich Bunting from the year 1580 AD shows

that despite the fact that the old view of the world had been adjusted to accommodate America, Jerusalem still remained at its center.

The third of the Abrahamic religions to honor Jerusalem is Islam. From its early days, the Islamic faith revered Jerusalem and highlighted its connection to Muslims. In the early years of the new faith, Muslims prayed facing Jerusalem, thus making it their *Qibla* (the direction of prayer). This continued to be the case throughout the Meccan period of Muhammad's life and for the first sixteen months following the *Hijra* to Medina (AD 622). Only then was the *Qibla* changed to Mecca. The Quran defended this change in *Surat al-Baqarah* (The Cow):

> The weak-minded will say: 'What has turned them away from the direction they formerly observed in Prayer?' Say: To Allah belong the east and the west; He guides whomsoever He wills onto a straight way (2:142).

The change in the *Qibla* in 624 AD signified the independence of the *Ummah* (Muslim community) from the older traditions of Judaism and Christianity. In more than one way, this change "marked a return to the primordial faith of Abraham before it was split into warring sects by the Jews and the Christians."[29] For by the mere choice of a new *Qibla* that had no association with earlier traditions, Islam was responding to the attachments of both Jews and *Jahiliya*[30] Arabs to a certain land.

According to Abul A'la Mawdüdï, a scholar and translator of the Quran, the original choice of Jerusalem as the *Qibla* was intended as a blow to the national pride of the Meccan Arabs and the subsequent change to Mecca was intended as a blow to Jews who "were obsessed with racial pride so that it was difficult for them to accept any other than the direction of Prayer which they had inherited with equanimity."[31] The basis for his analysis is the Quranic verse 2:143:

> We appointed the direction which you formerly observed so that We might know who follows the Messenger from him who turns on his heels.

Mawdüdï's interpretation reflects one possible understanding of the significance of the change of the *Qibla* but it does not explain the way Jerusalem came to be perceived by Muslims. For such

understanding is only possible if one examines both later Islamic literature and Islam's view of itself as the religion that completes both Judaism and Christianity. In *al-Baqarah* 135, the Quran instructs Muslims to declare: "We believe in Allah, and in what has been revealed to us and to Abraham, Ishmael, Isaac, Jacob and the descendants [of Jacob] and in what was given to Moses and Jesus." According to this view, the religion of Islam constitutes a legitimate heir to both previous monotheistic traditions and thus to their divine symbols. Therefore, previous attachments to Jerusalem by both religions were bound, directly or indirectly, to be inherited and emulated by Muslims. There are a number of examples that illustrate how Muslim authors borrowed and employed ideas and styles that could be traced back to either Judaism or Christianity. Amikam Elad, for example, argued that Al-Hasan Ibn Ahmad al-Muhallabi (d. 990), author of *al-Masalik-wa'l-Mamalik,* introduced ideas that were "mainly derived from Jewish *Midrash* and *Aggada.*"[32] Another Muslim author, the thirteenth-century geographer and preacher of the Umayyad mosque in Damascus, Burhan ad-Din al-Fazari (1262-1329), wrote that Jerusalem's significance to Islam was based on associations relevant to Christianity and to a lesser extent, to Judaism. He wrote the following account:

> ... Allah looks in mercy every day unto Jerusalem. Moses' staff shall appear at the end of time in Jerusalem. Allah announced to Mary the good news of Jesus in Jerusalem. Allah showed unto Mary favor above all women in Jerusalem. Angels descend every night unto Jerusalem. Allah prevents the enemy of Allah, the Anti-Christ, from entering Jerusalem. He shall conquer lands except Jerusalem and Mecca and Medina. Allah turned (with acceptance) towards Adam in Jerusalem.[33]

Three centuries before al-Fazari, the historian al-Tabari (839-923) had already established a connection between Adam and Jerusalem. He wrote that after Noah left the ark, he re-buried Adam in Jerusalem.[34] Although it is clear that Jerusalem is sacred to Islam for many of the same reasons it is sacred to Judaism and Christianity, its revered status obeys also to other reasons that are particular to Islam. These reasons are not mentioned directly in the Quran but, as in the case of Christianity, seem to have their roots in literature of later periods. The most important of these reasons is connected to the

Isra' and Mi'raj or the Night Journey of Muhammad, the prophet of Islam, to Jerusalem and his ascent from there to heaven. The events of this journey are mentioned in the Quran in Sura al-Isra', Verse 1:

> Glory be to the One who took his servant on a journey by night from Al-Masjid Al-Haram in Mecca to Al-Masjid Al-Aqsa whose precincts we have blessed.

While it appears that there was some disagreement among early Muslims concerning the details of the Night Journey — as al-Zamakhshari (d. 1144) informs us in his commentary on the Quran — a consensus among scholars existed a century later, on the events and the locations associated with the journey.[35] For the eighth-century biographer of Muhammad, Ibn Ishaq (d. 768) — who was the author of the earliest known detailed account of the Night Journey — there was no doubt that during his Night Journey Muhammad had gone to Jerusalem.[36] The reason for the confusion and debate among scholars over whether Muhammad's destination had been Jerusalem, is connected to the fact that Jerusalem, or Bayt al-Maqdis (the house of holiness) — as it was called by Muslims — is never mentioned by name in the Quran. This might explain why the city did not appear to have acquired a special place within the Islamic world-view until practically the period of the Umayyad Caliphate (661-750). And even then, its position was less prominent than that of Mecca and Medina. Still to the medieval Muslims, Jerusalem was a place that held a great deal of admiration, so much so, that it was often described by scholars, such as al-Fazari, as being "the treasure of the world."[37]

The case might very well be that the status of Jerusalem was a subject of debate among the Muslims during Islam's first century. For there are several *Hadiths* (sayings attributed to the Prophet) that show a tendency towards elevating Jerusalem to the same level as that of Mecca, particularly those circulating during the first half of the second century of Hijra (from AD 750).[38] One *Hadith* cited by Mujir Edin al-Hanbali states that prayer in Jerusalem is worth five hundred prayers in any other mosque (except for Mecca and Medina).[39] At the same time, there are reasons to believe that early Muslim authorities were actively opposing the idea of elevating Jerusalem to the level of Mecca. Mujir Edïn al-Hanbali pointed out that the second Caliph *Omar ibn al-Khatab* — who is credited with having

conquered Jerusalem from the Byzantine Empire in AD 638 — said that "we [Muslims] were not ordered to face the Rock [the current site of the mosque in Jerusalem] but the Ka'aba."[40]

Echoes of such sentiments continued to appear in the writings of some Muslim scholars as late as the fourteenth century. For example, Ibn Taimeyah (d. 1328) argued that Bayt al-Maqdis was but a copied *Qibla* and that whoever prayed toward it was an infidel (*Kafir*).[41] Nonetheless, it is safe to argue that Jerusalem has occupied a special place within the Muslim world-view since the second Islamic century. While it might not be possible to pinpoint a single most important reason why Jerusalem acquired its special status for Islam, it may be significant to note that some historians argue it was a product of the Umayyad period, particularly the caliphate of Abd-al Malik (647-705), the builder of the Dome of the Rock.

Some historians have argued that the building of the mosque in Jerusalem was an attempt by Abd-al Malik to undermine the importance of Mecca and Medina, which were both under the jurisdiction of the competing caliph, Abdallah ibn al-Zubayr. Sibt al-Jawzi (1186-1256), author of *Mir'at al-Zaman*, wrote that due to al-Zubayr's control over Mecca and his constant attacks on the Marwanïds (family of the caliph), Abd al-Malik banned Muslims from going on the *Hajj* (pilgrimage to Mecca). He ordered the construction of the mosques of the Dome of the Rock and the al-Aqsa in Jerusalem in the year 72 of the *Hijra* "in order to divert their [the Muslims] attention from the *Hajj*."[42] However, this view is not completely accepted by historians.[43] Many challenge its reliability on the grounds that it was first reported by historians who had an interest in undermining either the Caliphate of Abd al-Malik or the Muslim connection to Jerusalem altogether.[44] The argument was first presented by the ninth-century Shi'i historian al-Ya'qubi and it was then re-stated by the Christian historian Eutychius (d. 940).[45] However, regardless of the real reason behind the building of the Dome of the Rock, the fact remains that according to Muslim tradition, the rock in the mosque came from paradise and is in fact the foundation stone for the world upon which Noah's ark rested and on which Muhammad's footprint is inscribed. It is also, according to Islamic tradition, the rock on which Abraham (Ibrahim) was about to sacrifice his son and from which Muhammad ascended to Heaven during his Night Journey.

The source of such myths is not always clear. Nevertheless, it is interesting to note the similarities between the view reflected by European maps of the Middle Ages — in which Jerusalem was placed at the center of the earth — and the Islamic belief that the rock (of the Dome of the Rock) in Jerusalem is the foundation stone of the earth. The fact that several verses in the Quran and several *Hadiths* describe the significance of Bayt al-Maqdis for Islam has often lent support to many such myths. Despite doubts regarding the origin of the elaborate Muslim mythology regarding Jerusalem, the fact remains that for Islam Jerusalem was always a holy city whose designation as such continues to be highlighted through the names it is called by, Bayt al-Maqdis and al-Quds (the holy).

Although a consensus on the holiness of Jerusalem exists among all three Abrahamic religions (Judaism, Christianity and Islam), the three groups constructed, at least three separate "authoritative" histories regarding the sanctity of the city. Even though Judaism, Christianity and Islam share similar mythologies and beliefs and have the same roots, they have developed separately within different historical contexts. The attitudes developed by Judaism, Christianity and Islam regarding Jerusalem are not only products of how each religion first encountered the city but they also relate to the way in which each one of them defines itself as a community and to the particular attitude that the three religions adopt towards remembering past events. In the Jewish tradition, the establishment of the Jewish identity is intimately connected to the narratives of a sequence of historical events (Exodus, Babylonian Captivity, etc.), as they have been preserved in the religious texts. Remembrance in Judaism, *Zikhronot*, had become "a technical term through which expression is given to the process by which practicing Jews recall and recuperate in their present life major formative events in the history of their community."[46] In Christianity, remembrance came to mean something other than recalling historical events central to the formation of a community. For Christian history focuses mainly on one event, the Resurrection, and all other events in history are defined in relationship to it. The significance of this event lies in the fact that Christians believe in it (rather than on its relevance to the formation of a community of Christians). Remembering this event, therefore, has acquired more the sense of bearing witness to its truth than to recalling the events surrounding its history. Islam is, on the other hand, a religion whose conception of itself holds less

ambiguity and symbolism than the previous two religions. For Muhammad was not a distant prophet connected to the founding of the religion, the way Jesus was, but was the actual leader and sovereign of the first community. Remembrance or *Dhikr* in Islam came to mean the uninterrupted remembering of God, rather than of a sequence of historical events or places relevant to Islam. Eventually, *Dhikr* became a particular ritual practiced by Muslim Sufis who justify such ritual based on Sura 13:28 of the Quran that told Muslims that "verily by remembering God, hearts become calm."[47]

The conceptual differences discussed above between the three religions are very significant in considering how the faithful of the three religions came to relate to the physical place known as Jerusalem. In the case of Judaism, Jerusalem is relevant for its role in important events in Jewish history and remembering it is important for the unity of the community. In the case of Christianity, it is the location of the most important moment in Christian history; visiting Jerusalem could be of importance for the understanding of the Bible and the re-affirmation of one's faith. And in the case of Islam, Jerusalem's importance stems from its being an integral part of *Dar al-Islam* (the abode of Islam) socially, economically and politically speaking, as well as from its symbolic significance as the first *Qibla* and as the site of Muhammad's Night Journey.

Historical and textual research can, perhaps, challenge the authoritative narratives of the three faiths in many respects, but it can never undo the fact that such accounts existed and contributed, in fact, to the construction of the different meanings assigned to Jerusalem. Considering the various meanings that Jerusalem holds for each community is highly significant for the purposes of our study in nineteenth-century photographic representation. For it can help us understand the extent to which such meanings might have influenced the production of certain images of the city. Despite the fact that photographic images in the nineteenth century were predominantly produced by and for European Christians, the attitude of the photographers — as it was reflected in their work — does not only speak for their own Christian imagination of Jerusalem; it also reflects their attitude towards sites relevant to the other religions.

NOTES

1. Edward Relph, *Place and Placelessness* (London: Plon, 1976), 43, quoted in J. Gerald Kennedy, *Imagining Paris* (New Haven and London: Yale University Press, 1993), 7-8.

2. Mikhail Bakhtin, "Marxism and the Philosophy of Language" in *The Rhetorical Tradition: Readings from Classical Times to the Present*, Patricia Bizzell and Bruce Herzberg, eds. (New York: St. Martins/Bedford, 1990), 928.

3. James Duncan, *Place/Culture/Representation* (London and New York: Routledge, 1993), 43.

4. Edward Relph, *Place and Placelessness*, quoted in J. Gerald Kennedy, *Imagining Paris*, 7-8.

5. This concept was used by Albert Aghazarian in *The Middle East Report*, May-June 1993, p 13. It was also used by Amos Elon as the title of his 1989 book on Jerusalem.

6. Benjamin Mazar, "Jerusalem in Biblical Times" in *The Jerusalem Cathedra*, vol. 2., Lee Levine, ed. (Jerusalem: Yad Izhak Ben-Zvi Institute, 1982), 13.

7. Thomas A. Idinopulos, *Jerusalem: A History of the Holiest City as Seen Through the Struggles of Jews, Christians and Muslims* (Chicago: Elephant Paperbacks, Ivan R. Dee, Publisher, 1991), 60.

8. Quoted in J. Gerald Kennedy, *Imagining Paris*, 9.

9. *Ibid.*, 9.

10. Amos Elon, *Jerusalem: Battlegrounds of Memory* (New York, Tokyo and London: Kodansha International, 1995), 78.

11. F.E. Peters, *Jerusalem: The Holy City in the Eyes of Chroniclers, Visitors, Pilgrims, and Prophets from the Days of Abraham to the Beginnings of Modern Times* (Princeton: Princeton University Press, 1985), 34.

12. *Ibid.*, 34.

13. Amos Elon, *Jerusalem: Battlegrounds of Memory*, 66.

14. Quoted in *ibid.*, 34.

15. *Ibid.*, 66.

16. Elaine Pagels, *The Gnostic Gospels* (New York: Vintage Books, 1979), xxiii.

17. Eusebius Pamphili was the Bishop of Caesarea (northern coast of Palestine) and the author of *Vita Constantini* (The Life of Constantine). He also composed the *Onomasticon*, a book on the names of places mentioned in the scriptures. See Mary B. Campbell, *The Witness and the Other World: Exotic European Travel Writing, 400-1600* (Ithaca and London: Cornell University Press, 1988), 15-20.

18. P.W.L. Walker, *Holy City, Holy Places? Christian Attitudes to Jerusalem and the Holy Land in the Fourth Century* (Oxford: Clarendon Press, 1990), x.

19. *Ibid.*, 348.

20. Cyril was a native of Jerusalem who became its bishop only five years after joining the priesthood. For more details about his life see Shehadeh and Nicola Khory, *Khulasat Tarokh Kanisat Orshaleem al-Orthodoxiya* [Summary of the History of Jerusalem's Orthodox Church] (Aman: Al-shraq al-awsat printers, 1992), 14-18.

21. P.W.L. Walker, *Holy City, Holy Places? Christian Attitudes to Jerusalem and the Holy Land in the Fourth Century*, 317.

22. Donald R. Howard, *Writers and Pilgrims* (Berkeley: University of California Press, 1980), 11.

23. Norman Cohn, *The Pursuit of the Millennium*, 2nd ed. (New York: Harper and Brothers, 1961), 44-45 quoted in Howard, *Writers and Pilgrims*, 13.

24. *Ibid.*, 13.

25. *Ibid.*, 13.

26. H.F.M. Prescott, *Friar Felix at Large: A Fifteen-century Pilgrimage to the Holy Land* (Westport, CT: Greenwood Press, 1950), 114.

27. See Donald R. Howard, *Writers and Pilgrims*, 54.

28. See Stephen Greenblatt, *Marvelous Possessions: The Wonder of the New World* (Chicago: The University of Chicago Press, 1991), 27-51.

29. Karen Armstrong, *Jerusalem: One City, Three Faiths* (New York: Alfred A. Knopf, 1996), 223.

30. The term *Jajiliya* — which means the age of ignorance — was used by the Quran to refer to the pre-Islamic period of Arabia.

31. Sayyid Abdul A'la Mawdudi, *Towards Understanding the Quran* (English version of *Tafhim al-Quran*) vol. I (Leicester, UK: The Islamic Foundation, 1989), 122.

32. Amikam Elad "Why did 'Abd al-Malik build the Dome of the Rock? A re-examination of the Muslim sources," in *Bayt al-Maqdis: 'Abd al-Malik's Jerusalem*, Julian Raby and Jeremy Johnes, eds. (Oxford: Oxford University Press, 1992), 45.

33. Burhan ad-Din al Fazari, "On the Merits of Jerusalem and Palestine," in *From Haven to Conquest: Readings in Zionism and the Palestine Problem until 1948*, Walid Khalidi, ed. (Beirut: The Institute for Palestine Studies, 1971), 32.

34. Al-Tabari, *The History of al-Tabari*, vol. 1, *General Introduction from the Creation to the Flood*, trans. Franz Rosenthal (State University of New York Press, 1989), 334.

35. See al-Zamakhshari's account in F.E. Peters, *Jerusalem*, 183.

36. See Ibn Ishaq's account in F.E. Peters, *Jerusalem*, 185.

37. Burhan ad-Din al Fazari, "On the Merits of Jerusalem and Palestine," 31.

38. A. Hassoun's introduction to Abi Bakr Ben Ahmad al-Wasiti, *Fadha'l al-Bayt al-Muqadas* (Jerusalem: Hebrew University of Jerusalem, 1979), 11.

39. This *Hadith* is attributed to Abi al-Darda' and was collected by Imam Ahmad. It is also quoted in Mujïr Edïn al-Hanbali, *Al U'ns al-Jaleel bi-tarikh al-Qudsi wal-Khalil* (Amman, Jordan: Al Muhtaseb Books, 1973), 229-230.

40. Mujïr Edïn al-Hanbali, *Al U'ns al-Jaleel bi-tarikh al-Qudsi wal-Khalil* (Amman, Jordan: Al Muhtaseb Books, 1973), 227.

41. See A. Hassoun's introduction to Abi Bakr Ben Ahmad al-Wasiti, *Fadha'l al-Bayt al-Muqadas*, 14.

42. Translated in Amikam Elad, *Medieval Jerusalem and Islamic Worship: Holy Places, Ceremonies, Pilgrimage* (Leiden; New York: E.J. Brill, 1995), 53.

43. This position has been recently revived by a number of Israeli historians; nonetheless, a number of other Muslim accounts that correspond with al Jawzi's exist. The earliest of these is that of al-Ya'qubi from around AD 874. Similar view was also expressed by Ibn Kathïr (1300-1373) in his book *al-Bidaya wa'l-Nihaya*.

44. Mahmoud Ibrahim rebuffs the idea that Abd al-Malik issued a ban on Muslim pilgrimage to Arabia by pointing out that al-Ya'qubi himself had pointed out that Abd al-Malik and many other Umayyads had gone on pilgrimage to Mecca between the years 72 and 85 AH. See Mahmoud Ibrahim, *Fadail Bayt al-Maqdis fi Makhtotat Arabia Qadima* (Kuwait: Institute of Arab Manuscripts, 1985), 56.

45. Amikan Elad "Why did 'Abd al-Malik build the Dome of the Rock?" in *Bayt al-Maqdis: 'Abd al-Malik's Jerusalem*, Julian Raby and Jeremy Johns, eds., 40.

46. Paul Connerton, *How Societies Remember* (New York: Cambridge University Press, 1989), 46.

47. Annemarie Schimmel, *Islam: An Introduction* (Albany, NY: State University of New York Press, 1992), 111.

JERUSALEM IN
NINETEENTH-CENTURY PHOTOGRAPHY

The nineteenth century marked the beginning of a new era in human perception and memory. Technological and scientific developments were reshaping human thinking and knowledge in ways that had never been possible before. Inventions in communications, both aural and visual, changed human perception of time and space drastically. It was becoming possible to communicate instantly with someone at the other end of the world and to view images of things, people, and events that were distant in space and time. Photography was at the center of these developments.

With the fixed photographic image, it became possible to preserve the past mechanically "with all the clutter of detail that painting and the theater leave out;"[1] it became possible to preserve the past in a way that human memory would never be capable of doing. Photography was bringing "the past into the present more than ever before, changing the way people experienced their personal past and the collective past of history."[2] This mirror with memory, to use the words of Oliver Wendell Holmes,[3] provided a sense of continuous existence of the past. It had the power to preserve the present forever and enabled the viewer, for the first time, to see images of people and places in far away lands whose existence had previously belonged, for the most part, in the realm of imagination.

But the assumption that photography renders its subject exactly as it exists is highly questionable. Not only do photographers manipulate reality through the use of special settings, effects, techniques, lighting and positions, but the photograph itself acquires various meanings depending on the viewers' previous knowledge of its subject and his reaction to it. In other words, the photograph — which originates as a product of a special relationship between the photographer and his subject — gets transformed by virtue of a special relation between the subject and the viewer. These relationships incorporate not only aesthetic considerations, but ideological ones as well. In this sense, the photograph is a tool of power and authority through which both the photographer and the viewer, through their gaze, conquer the world of the subject and assign meanings to it.

Photographs, then, must be regarded as visual documents that can not be separated from the historical conditions in which they

were produced and in which they are viewed. Sarah Graham-Brown suggests a number of elements that should be taken into consideration when studying photographs, namely, the context in which the photograph was taken; the relationships of power and authority between photographer and subject; the aesthetic and ideological considerations which affected the photographer's choice of subject; and the way the photograph might be interpreted by its viewers in a particular historical period.[4] The present collection of nineteenth-century photographs of Jerusalem, then, should be viewed in this context. As historical documents they reflect not only the way the city appeared at the time but, more importantly, various attitudes and conceptions prevalent in European imagination. But this is not a one way process, for at the same time, the photographs themselves have the power to shape and reshape the very same imagination they reflect. In the words of Susan Sontag "photographs alter and enlarge our notions of what is worth looking at and what we have a right to observe."[5] In examining nineteenth-century photographs of Jerusalem, we need to take into consideration some of the ideological and political issues that influenced the way European photographers related to Palestine at the time.

PHOTOGRAPHY AND REPRESENTATION
OF THE ORIENT AS THE OTHER

Nineteenth-century photographic interest in Jerusalem was very much linked to a complex web of European connections to the Near East at large. Prominent among such connections were a colonial and a scientific interest in the region, a romantic passion for imaginary exotic sites and a revived Christian interest in Biblical studies. The decision of European photographers to travel to Palestine was very much connected, directly or indirectly, to one or more of these factors.

The photographic process developed at the time of the height of European expansionism. Napoleon's conquest of Egypt in 1798 — and his failed attempt to conquer Palestine two years later — signaled the beginning of a new European interest in the affairs of the Near East. Soon after Daguerre's announcement of his photographic invention in 1839, many French and, shortly after, British photographers traveled to different parts of the world to bring back with them visual evidence of the wonders that existed beyond the imaginary boundaries of the Western European world. Among the

many places that attracted photographs were Egypt and Palestine, the two regions whose connection to European thought and tradition goes as far back as the age of antiquity. As a matter of fact, only a few months after Daguerre's announcement, the first photographers arrived in Palestine; Horace Vernet and Frédéric Goupil-Fesquet arrived in December 1839 to photograph the country.

The introduction of photography in the Near East coincided with a rising archeological interest in the region which, in many ways, was also a consequence of Napoleon's adventurous war in Egypt. For when he and his army arrived in Egypt, they had with them more than 500 civilians, 151 of whom were members of the special *Commission des Sciences et Arts*.[6] The result of the work of the commission was published in the voluminous survey entitled *Description de l'Egypt.*

The rising interest in the region's past, as well as in other cultures, was related to a process in which Europe sought to define itself through comparison with other cultures that were viewed as less advanced. This process, it could be argued, is connected to Darwin's theory of evolution and Spencer's theory of social evolution. Europeans were increasingly interested in representing other cultures as if they were explaining how their own ancestors once lived. In other words, other cultures were made to fit into a particular context in which Europe was seen as the highest stage in the process of historical evolution. Other civilizations' contributions to humanity were considered only inasmuch as they were of some importance to western civilization. Evolution, thus, stopped to be only a temporal relation, and was transformed into a spatial one as well. *Beyond* Europe was henceforth *before* Europe.[7] The archeological survey of Egypt during the Napoleonic rule and the unearthing of the sphinx provided an important boost to European studies of the Orient. Eventually, photography began to be employed extensively in such studies. Many archeological societies that were formed during the nineteenth century with the specific purpose of studying different parts of the ancient world dispatched photographers along with their archeologists. In 1859 the French photographer Louis de Clercq accompanied an archeological expedition to the Near East which was headed by the historian Emmanuel Guillaume Rey. As a result of his trip, de Clercq published a five-volume series of albums entitled *Voyage en Orient*. It contained 177 photographs of Syria, Palestine and Egypt.[8]

This image of the Orient was not limited to paintings but could be found in photography as well. It is very likely that many of the early photographers who traveled to the East imagined their destination to look like something similar to what they saw in Gérôme's paintings, especially if they thought that the painter had used photographs to help him depict the Orient. As Donald Rosenthal has pointed out in his study of the Near East in nineteenth-century French painting, painters "frequently were dependent on photography in their major Orientalist works."[15] Jean-Léon Gérôme himself was thought to have had great interest and enthusiasm in photography and Rosenthal has noted that a number of his paintings were, in fact, based on photographs taken at the sites. Rosenthal's persuasive argument rests on a comparison between a number of photographs and several of Gérôme's paintings. For example, by comparing Gérôme's 1863 painting *Napoleon in Egypt* with Robertson and Beato's 1856 photograph of the Mameluke Tombs in Cairo, he shows that apart from Napoleon's portrait — the main theme of the painting — the tombs in the background appear to be identical to those in the scene depicted in the photograph, in terms of perspective.

In turn, photographic images of the Near East often corresponded to the idea of the exotic Orient which was present in romantic literature. Writers who visited the Near East were often either accompanied by photographers or acted as photographers themselves. Gustave Flaubert, who depicted the East in his works as an exotic place full of harems, traveled to the region in 1849-1850 accompanied by Maxime du Camp. As a result of this trip, du Camp who became known as one of the earliest photographers of Egypt and Palestine — published his calotypes (early form of photographs) in Gide and Baudry's album entitled *Egypte, Nubie, Palestine and* [...].[16]

There was still another important factor which motivated European photographers during the nineteenth century to capture the East — and in particularly Palestine — in their works; a revived Christian interest in the Bible. Studying the sites where biblical events were thought to have taken place became part of a new movement aimed at providing evidence of the accuracy of the biblical narrative.[17] Photography was extensively employed in such studies. The American photographer Dwight L. Elmendorf, for example, journeyed to Palestine in 1901 with the specific purpose of improving his understanding of the Bible. In the preface to his

A very important factor that appears to have stimulated a photographic interest in the East during the nineteenth-century was the emerging romantic passion towards the Orient. The image of the East as an almost fictitious site with an exotic mystique was being continuously reproduced by Romanticism and its historicized exoticism. This passion was expressed through many forms of arts and literature. The poetry of Hugo and Gérard de Nerval, the paintings of Jean-Léon Gérôme, Delacroix and David Roberts and the novels of Flaubert are but a few examples of the many works tha depicted an exotic Orient.[9] Both Hugo and de Nerval wrote of tl Orient as an "image" or "pensée,"[10] which immediately fades aw after any actual encounter with the East. De Nerval — in a lette' wrote to Théophile Gautier in August 1843 — lamented his lo' the Orient after having visited the East:

> ...and soon I will know of no place in which I can fin'
> refuge for my dreams; but it is Egypt that I most regr(
> having driven out of my imagination, now that I have sad
> placed it in my memory.[11]

In the paintings of Gérôme, Manet, Delacroix and Ingres Orient of the imagination, lost by de Nerval, which cont' historicized. Despite their stylistic differences, they all the East through similar themes. In Jean-Léon Gérôm *The Snake Charmer*, for example, a naked young ma' holding a snake while he faces a group of men dressed' to be Arab garments.[12] However, the painting's ti' *Charmer* does not tell the entire story. Although th' show a young man with a snake, its main point of snake or the performer but the latter's audienc(huddled against the ferociously detailed tiled wa' included in the gaze of the viewer."[13] Linda N(should be called "the snake charmer and his a' words, the painting is really about the painter' audience and, by extension, of an entire cultu' senting the Orient which might have been ' enabled the viewers to peek into an exotic with hidden secrets, nude boys and gazing au of the Orient illustrated in the painting corr East than to the East portrayed in certain b in Europe at the time, such as the *Thousan(*

photographic book, entitled *A Camera Crusade Through the Holy Land*, he wrote:

> In 1901 I started for the Holy Land…simply to journey through the land with a desire to see for myself places mentioned in the Bible, to study ancient customs which still remain, and if possible to understand the significance of many sentences in the Scripture which were very obscure to me and to those who tried to teach me; in fact, my faith was wavering, I was in doubt, yet one verse in Matthew compelled me to go: "Ask, and it shall be given to you; seek, and ye shall find; knock, and it shall be open unto you." I went, I asked, I knocked: I doubt no longer, now I know. The journey on horseback through the Holy Land was a revelation to me; may my description of it be a help to many.[18]

Elmendorf's crusade has left us with one hundred illustrations of various locations in Palestine to which he, guided by his Bible, assigned biblical meanings. Elmendorf's attempt to photograph the Holy Land as a familiar site most relevant to the Bible was not only common to western travelers to Palestine in the nineteenth century, but echoed the sentiment that dominated in Europe during the middle ages, that Jerusalem was a divine heritage that Europeans longed to possess.

Common among missionaries and pilgrims, Elmendorf's sentiment was also reflective of how many European photographers viewed their mission in Palestine. Writing about his reasons for photographing Egypt and Palestine, the British photographer Francis Frith alluded to his childhood's religious imagination. Describing the two countries as "the two most interesting lands of the globe," in an article that appeared in *The British Journal of Photography* in February 1860, Frith stated:

> There are but few persons in whom any mention of the localities above named does not stir up deep and lively emotions; and no wonder that it is so, for not only do the Holy Scriptures teem with direct references thereto; both Old and New Testaments, but they are also continually alluded to in a spiritual sense when treating future state of existence.[19]

The Scottish photographer John Cramb was even more explicit about the reason why he had been sent to photograph Palestine. In an article that also appeared in *The British Journal of Photography*, he wrote that the specific reason for his 1860 visit to the Holy Land had been "purely to get pictures of places interesting from Scriptural associations."[20]

PHOTOGRAPHERS OF JERUSALEM

In light of the above elements that sparked the photographic interest in Palestine, it should be no surprise that the small provincial town of Jerusalem became a place whose pictures and images were very popular in Europe. In both art galleries and photographic exhibits, depictions of the city were more readily available than those of any other Asian or African city. Finding photographs of Jerusalem exhibited alongside those of Paris and London appears to have been somewhat common. The following description of an architectural photographic exhibit published in *The British Journal of Photography* on March 15, 1860, provides a good indication of this:

> The photographs in this exhibit are judiciously classed by countries, although the various nations are unequally represented. France and England are greatly in the majority, as might have been expected: next follow Spain, Rome Venice, Jerusalem and its neighborhood.[21]

The exhibited photographs were those of Robertson and Beato, two wet-plate photographers we have mentioned before who visited Palestine in 1857. In describing the pictures, the reviewer also stated that the buildings of Jerusalem "seem[ed] as familiar as...the public buildings of London."[22] Indeed, Jerusalem was a well known place for the Europeans of the time. According to Reinhold Rohricht's bibliography more than two thousand books were written about Palestine (mostly by European authors) between 1800 and 1878.[23] And according to Nissan Perez more than two hundred and fifty different photographers worked in the Near East between the years 1839 and 1885, many of whom photographed Jerusalem.[24] The number of photographers of course would have been significantly higher had the latter date been the turn of the twentieth-century for the gelatin plate negative and the transparent nitrocellulose film — developed by George Eastman in 1888 and in 1891 respectively —

made photography easily accessible to a wider public. The new types of negative freed photographers from having to carry along the bulky glass negatives that had been previously used and enabled tourists to take their own cameras along with them to the various places to which they traveled. While it would be impossible to estimate how many such amateur photographers took pictures of Jerusalem in the nineteenth-century, it is likely that the number was very large.[25]

The images produced by professional photographers varied in terms of their subject matter and potential viewers. Different kinds of photographers, produced different kinds of images. This variety in the types of image was often connected to the reason photographers went to Palestine in the first place. Many photographers were sent to the region by various types of agencies, with presumably different goals. We would like to propose the following classification of photographers solely based on the kind of affiliations they had and the type of photographs they produced. It is very possible however, that some photographers may belong in more than one category, since they might have been motivated to photograph Palestine by more than one reason.

The first type of photographers included those who were dispatched by governmental agencies. Maxime Du Camp and Auguste Salzmann were two such photographers, sent to the Near East by French governmental agencies. Du Camp — generally thought to be the first to use calotype photography in the Middle East — was sent by the French Ministry of Education on an official mission to Egypt and Palestine in 1849 together with his friend Gustave Flaubert.[26] Auguste Salzmann — originally a painter — was sent by the French Ministry of Public Instruction to document Jerusalem and its environs in 1855 with the purpose of validating the theories of Louis Ferdinand de Saulcy.[27]

The second type of the photographers included those who were sent by scientific or archeological organizations. Among them, Louis de Clercq accompanied the French archeological expedition to the Near East headed by Emmanuel Guillaume Rey in 1859. He published a series of albums under the general title of *Voyage en Orient*.[28] Similarly, several British expeditions, mostly organized by the Palestine Exploration Fund — from the 1860s on — included photographers as part of their teams. Among such photographers were Henry Phillips, James McDonald and Horatio Herbert

Kitchener.[29] The Beirut based photographer Dumas also worked in the 1870s for the American Oriental Society.

The third type was constituted by either missionaries or photographers sent by religious organizations. This group includes many of the commercial resident photographers of our next type who were commissioned occasionally to do such work. They also include well known missionaries and counselor staff such as James Graham who was appointed as the lay secretary of The London Society for the Promotion of Christianity among the Jews in 1853. He stayed in Palestine for a period of three years during which he photographed many sites relevant to Biblical history.[30]

The fourth group was the resident photographers who established their own studios in Jerusalem, Beirut, Istanbul or Cairo. These were usually Europeans who came to the region as part of one of the above mentioned groups and who stayed behind to work permanently in the region. Among the resident photographers were Félex and Lydie Bonfils who moved from France to Beirut and established a photographic studio in 1867. They, along with their son Adrien, photographed the Near East extensively from 1867 until the early part of the twentieth century.[31] Another European whose studio competed with the Bonfils establishment was Tancrède R. Dumas whose arrival in Beirut seem to have coincided with that of the Bonfils'.[32] Several European photographers established studios in Istanbul, the capital of the Ottoman Empire. They include J. Pascal Sebah — who established a large studio in 1868 — and the brothers Horsep, Vichen and Kevork Abdullah—who in 1862 were appointed as court photographers to Sultans Abdul Aziz and Abdul Hamid.[33] Others settled in Egypt and established studios at Cairo, Alexandria and other cities. They include L. Fiorillo, an Italian photographer who established his studio in Alexandria in the 1870s. Fiorillo's business seems to have merged with that of another photographer in the 1880s. The signature Marquis and Fiorillo appears on all of his later photographs.[34] The photographs signed by Zangaki also seem to belong together with this group, despite the fact that we are not certain whether he was a resident photographer or not. The photographs taken by Zangaki cover an extensive part of the region over a period of time that extends from the 1870s to the turn of the twentieth century. We lack any solid information about this photographer, but it appears that we are dealing with more than one person working together under the same name. Nissan Perez has suggested

that they were two brothers of Greek origin, one of which appeared often in the photographs wearing a straw hat.[35] Chevedden has suggested that the two photographers were H. Arnoux and G. Zangaki whose studio was in Port Sa'id.[36]

The last group of photographers included those who were commissioned to produce stereoscopic images. This groups involves a large number of photographers, the majority of whom were Americans or worked for American distributors. Among them were William E. James (who produced a series of 150 images of Palestine in 1866), Benjamin West Kilburn (whose photographs date from 1865 and 1874) and William Herman Rau (who took a number of stereoscopic images during 1882).[37] The Scottish John Cramb was commissioned to produce stereoscopes by publisher William Collins of Glasgow in 1860 and the British photographer Frank Mason Good also took stereoscopes in the 1860s.[38]

REPRESENTING JERUSALEM: THE IMAGE OF THE CITY IN EARLY PHOTOGRAPHY

Although photographers traveled to the Near East for various reasons, it could be argued, that their common aim was to define the Orient visually. In doing so, photographers often imitated each other's work and reproduced conceptually ideas and images that were already in existence. Therefore, it is no surprise that in their photographs of Jerusalem, photographers followed certain patterns in regards to themes, styles, locations and techniques. The frequency of the recurrence of such patterns in the commercially distributed photographs indicates that there was a tradition of strong uniformity in context, subject, aesthetics and textual commentary. An overview of nineteenth-century photographs of the city taken by photographers from all the above types, reveals the recurrence of the following patterns: (1) the predominance of religious sites, (2) the absence of local population, (3) the objectification of the human figures as living proof of biblical heritage, (4) the staging of biblical scenes, (5) the absence of nude models, and (6) the photographing of similar locations from similar angles.

The first of these patterns, and the most obvious, points to the fact that the overwhelming majority of the photographs were of sites connected with biblical history. The main Churches of Jerusalem, such as the Church of the Holy Sepulcher, the Church of the Ascen-

sion, the Ecce Homo Arch, and the Garden of Gethsemane were among the most popular sites to be photographed. Other locations — not necessarily marked by a church but known to have some biblical association — also appeared frequently in the photographs. The village of El-A'zariyeh (referred to in the pictures as Bethany), the valley of the kings, and the mount of Olives are typical examples. It is particularly significant that the captions for such photographs — as in the case of El-A'zariyeh — almost always gave the biblical names rather than the names used by the residents of Jerusalem at the time. The most striking example of this is the continuous reference to the mosque of the Dome of the Rock — a marvelous architectonic Islamic shrine — as *The Site of Solomon's Temple.* The persistent attitude of ignoring the existence of the mosque went even further in some cases. On his 1854 photograph of the Dome of the Rock, the Scottish James Graham printed Luke 21:37 onto the negative.[39] The verse states that "in the day time He was teaching in the Temple and at night in the mount called the Mount of Olives." It is rather ironic that the European photographers were able to see on that site what had existed two thousand years before and to ignore what was there before their own eyes. Perhaps in many cases, such "blindness" was simply the result of the market demand in Europe for Holy Land photographs, since they were often used to illustrate bibles, pilgrim's narratives and other religious books, following the tradition already set by painters and engravers.

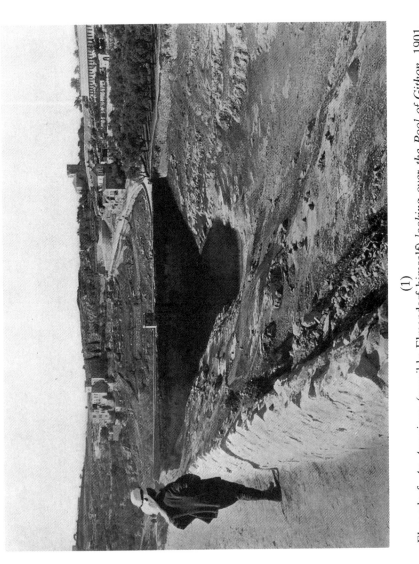

(1)

Elmendorf, *An American* (possibly Elmendorf himself) *looking over the Pool of Githon*, 1901, from **A Camera Crusade Through the Holy Land**, private collection

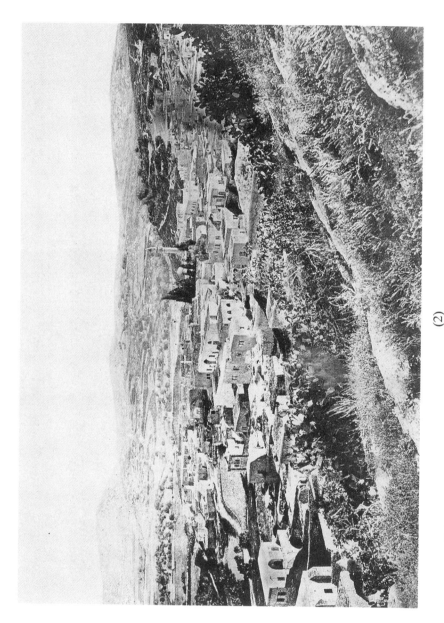

(2)

Frith, *A general view of Nazareth*, 1858–1860, Mohammed B. Alwan Collection

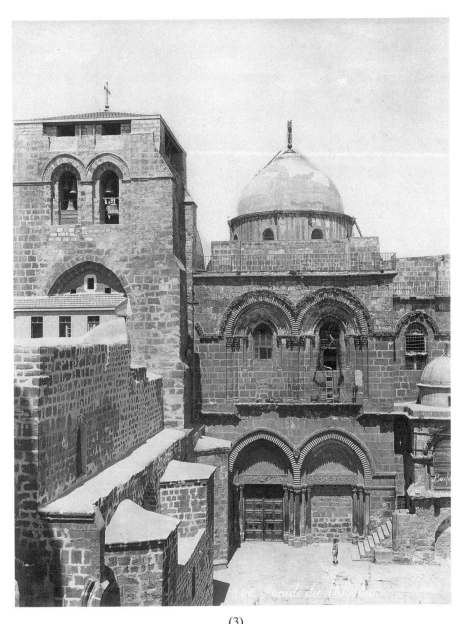

(3)
Bonfils, *Church of the Holy Sepulchre*, 1870s, Mohammed B. Alwan Collection

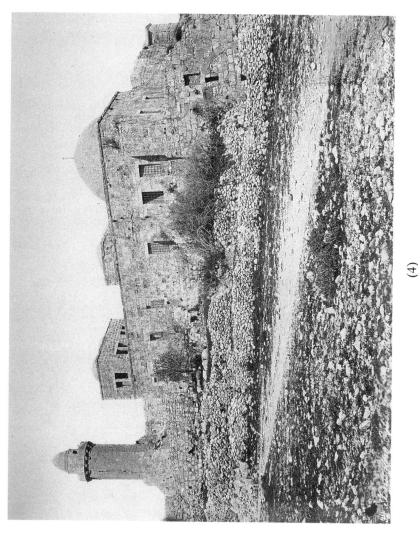

(4)

Bonfils, *Mosque of the Ascension*, 1870–1890, Mohammed B. Alwan Collection
Until its conversion into a mosque in 1198, this building was a Christian church.

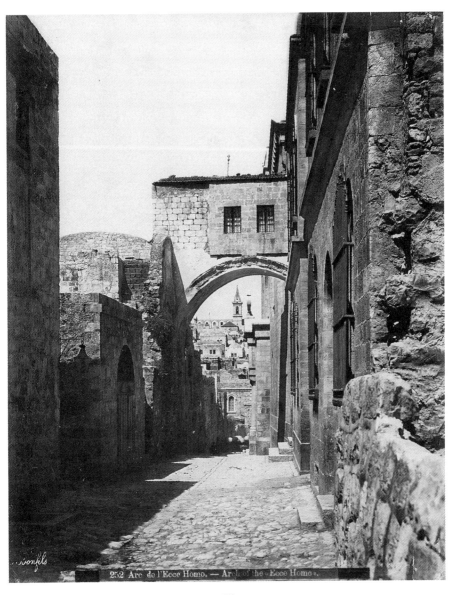

(5)
Bonfils, *The Ecce Homo Arch on Via Dolorosa*, 1880s,
Mohammed B. Alwan Collection

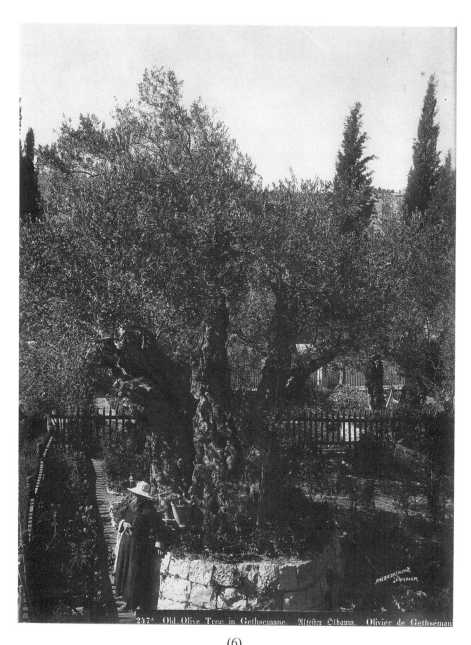

247ᴬ Old Olive Tree in Gethsemane. Ältester Ölbaum. Olivier de Gethséman

(6)
American Colony, *The Garden of Gethsemane on Mount of Olives*, around 1900,
Mohammed B. Alwan Collection

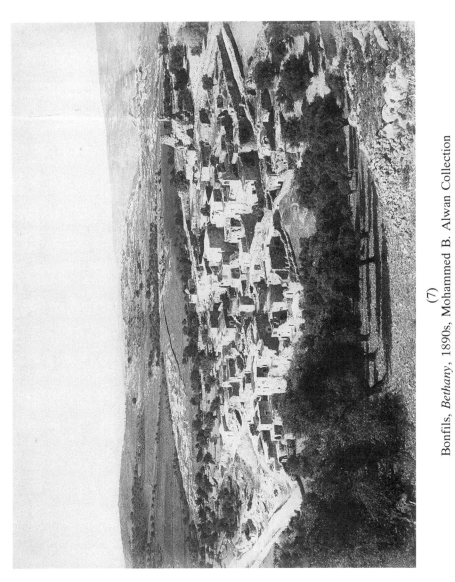

(7)

Bonfils, *Bethany*, 1890s, Mohammed B. Alwan Collection

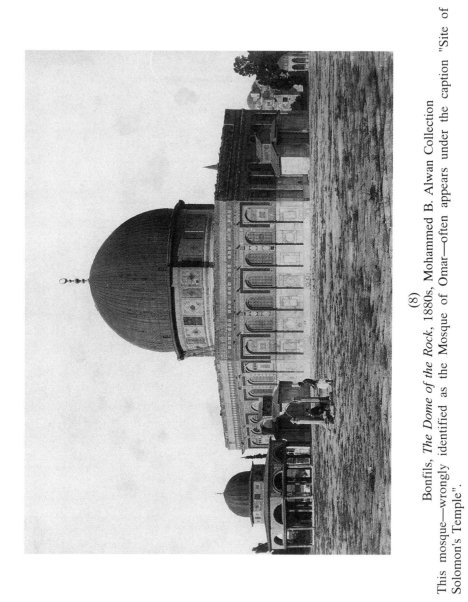

(8)

Bonfils, *The Dome of the Rock*, 1880s, Mohammed B. Alwan Collection

This mosque—wrongly identified as the Mosque of Omar—often appears under the caption "Site of Solomon's Temple".

The second pattern in the photographs is the general absence of the local population. It is hard to find any human figures in the early photographic images of Palestine, particularly in those dating from before 1867. The work of Maxime Du Camp, Auguste Salzmann, Robertson and Beato and Francis Frith — who photographed Jerusalem during the 1850s — illustrate this point. It was not until the late 1860s that human figures started to appear more frequently in photographs. It is striking that only a few of the photographs of Henry Phillips depicted people,[40] particularly in view of the fact that he had been sent to Palestine with the specific purpose of documenting the country. Even in the Holy Land photographs of Bonfils (late 1860s, 1870s and 1890s) — famous for their staged studio portraits — human figures continued to be absent from pictures of biblical and historical sites. For example, we notice the complete absence of people from any of their photographs of the Dome of the Rock. In the photographs of the same location by M. J. Dines (1858), we occasionally see a handful of human figures, but always from a distance. Many other important locations, such as the Church of the Holy Sepulcher, streets of the Jerusalem, Damascus Gate, and the Wailing Wall, often appeared either empty or with a handful of people fully subordinated to the landscape. These images provoke in the viewer the feeling that Jerusalem was an empty place, for some of the most lively places of the town were reduced to sites of ancient uninhabited ruins.

There are few typical occasions when this rule seems to have been broken. Many photographs of the front of the Holy Sepulcher were taken during the busy season of Easter, when large crowds could be seen. Despite their popularity, these photographs do little to undermine the image of Jerusalem as an empty place because of the association of the large crowd with a special season. Furthermore, when captions were used, they seemed to have had the effect of downplaying the significance of the people present in the pictures. A good example is the photograph taken by Dwight Elmendorf in 1901 of the outside of the Church of the Holy Sepulcher on the day of Easter, in which we see the crowds attempting to enter through the doors of the Church. The caption to the photograph, *The Throng of Pilgrims and Others*,[41] however, might indicate the reason behind his photographing human figures. While by describing some of the people in the photograph as pilgrims, the caption emphasized the authenticity of the location as a holy site, it continued to undermine

the mere presence of a local population in the city by reducing them in the photograph to merely the *others*.

No doubt, certain technical limitations (such as the long exposure time needed to capture an image photographically) had an important impact on the photographers' choice not to photograph moving objects. However, it is highly doubtful that these limitations were the only reason why human figures did not appear in the early photographs of Jerusalem. Even though Maxime Du Camp used the calotype process,[42] he was able to capture some human figures in his photographs of Egypt. That he succeeded to film people in Egypt, perhaps through payment to the posing Egyptians, indicates a decision on his part not to do the same in Palestine. Similarly, McDonald and Philips, among others, often had a human figure in their photographs of archeological sites, most likely with the purpose of establishing a sense of scale. Other early photographers whose work focused on religious sites also used human beings in a similar way. A few photographs by James Graham, Robertson and Beato illustrates this point. Furthermore, a number of early local photographers of Jerusalem (e.g., M.J. Deniss and the photographers of the Armenian convent) produced portraits of several notable individuals from the city, including a number of Armenian figures and of local Ottoman leaders. It is also significant in this context that some of the same photographers of Palestine were able to take countless images of human figures, such as women in harems in other parts of the "Orient." Despite the limitations, technical and otherwise, nineteenth century photographers could have captured people in their photographs of Palestine, had they wished to do so.

The absence of the Palestinian population from most photographs was partially due to their own hostility towards the intruding European photographers and their intimidating cameras which violated religious codes sacred to both Muslims and Jews. But this was probably not the only reason. Chances are, the absence of the Palestinian population reflected the fact that they were also absent, at some level, from the mind and consciousness of the European, or American, photographer. In his mind, the city was reduced to a location that could attest to the truth of the biblical story, rather than recognized as a real place in this world. The American photographer Edward L. Wilson, who photographed Palestine in the 1880s, corroborates this point in a striking way. In an article that appeared in *Century Magazine*, Wilson actually stated that the

peasants he encountered near the Sea of Galilee were "repulsive" adding that "they are entirely out of harmony with the character of the Land."[43] But it is interesting to note that even the photographers who, unlike Wilson, were favorably impressed by the people of Palestine avoided including them in their photographs. The Scottish photographer John Cramb wrote of his disappointment at not being able to photograph the women of Bethlehem whom he thought were beautiful. Reporting on his 1860 journey to Palestine, he wrote:

> The women of Bethlehem are generally fair and always beautiful. Every traveler remarks that.... Sincerely did I regret the arrangement that denied me the pleasure of bringing home witnesses to the correctness of my judgment. But I was not expected to spend my time on such subjects, though I now think it a pity that I was so scrupulous in the discharge of my duty.[44]

It would appear that other photographers, like Cramb, thought that their buyers would resent having photographs of important sites being desecrated by the inclusion of Arabs, Turks and Jews.[45] This "amazing ability to discover the land without discovering the people,"[46] to use the words of Beshara Doumani, might have very well paved the ground for the emergence of the popular mythical image of Palestine as a land without a people, which became a slogan of the Zionist movement half a century later.

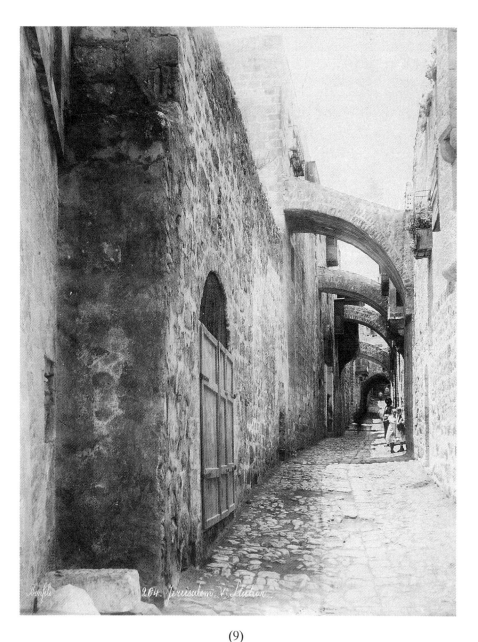

(9)
Bonfils, *The V. Station of the Cross on Via Dolorosa,* 1870s,
Mohammed B. Alwan Collection
Christians believe that this is the road on which Jesus carried his cross on his way
to Golgotha. The authenticity of this place is highly questionable and is really
based on a tradition that goes back only to the late medieval period.

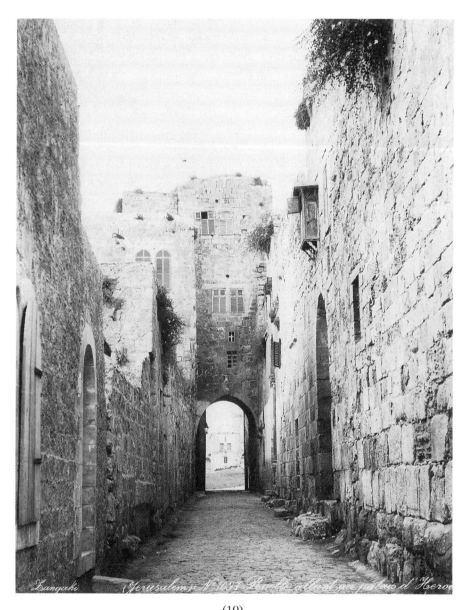
(10)
Zangaki, *A Street in the Old City*, 1880–1890, Mohammed B. Alwan Collection

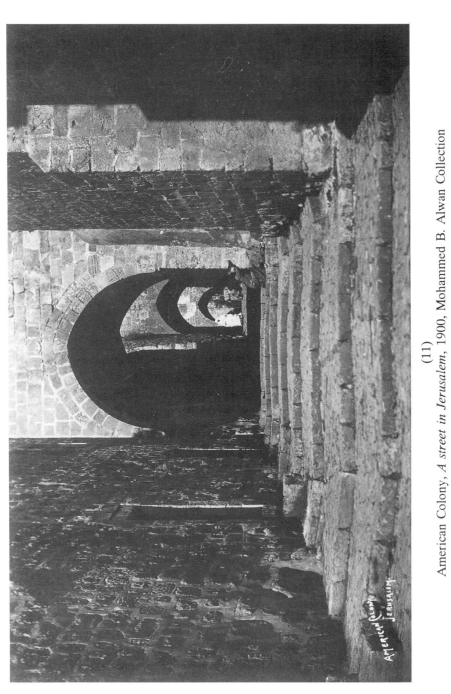

(11)

American Colony, *A street in Jerusalem*, 1900, Mohammed B. Alwan Collection

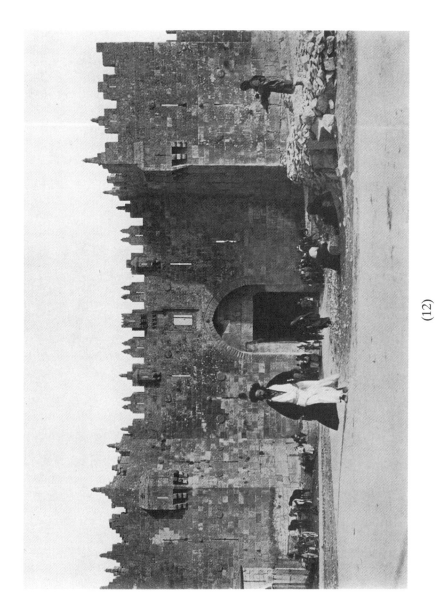

(12)

Elmendorf, *Damascus Gate*, 1901,
from **A Camera Crusade Through the Holy Land**, private collection.

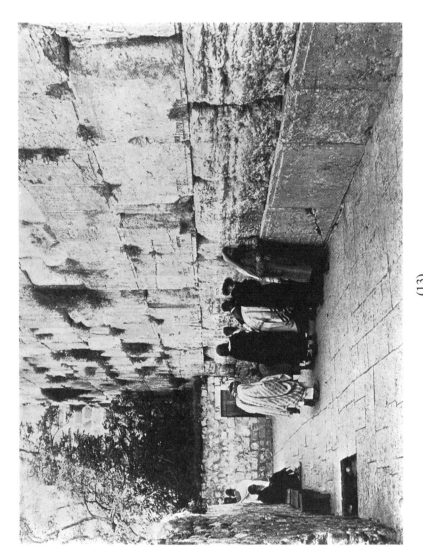

(13)

Elmendorf, *Wailing (Western) Wall*, 1901,

from **A Camera Crusade Through the Holy Land**, private collection.

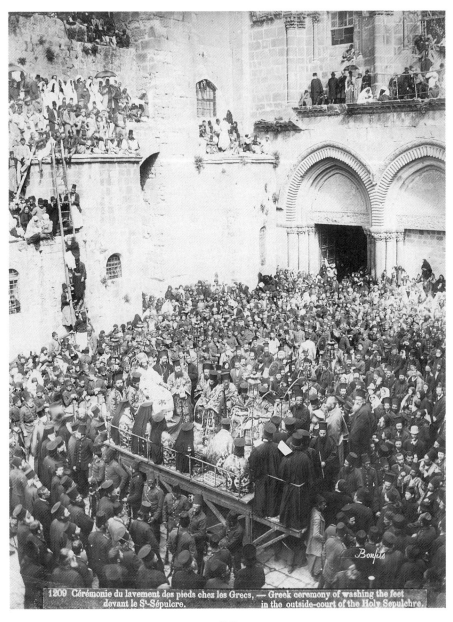

1209 Cérémonie du lavement des pieds chez les Grecs, — Greek ceremony of washing the feet
devant le S^t-Sépulcre. in the outside-court of the Holy Sepulchre.

(14)
Bonfils, *Ceremony of washing the feet in the Court of the Holy Sepulchre*, 1890s,
Mohammed B. Alwan Collection

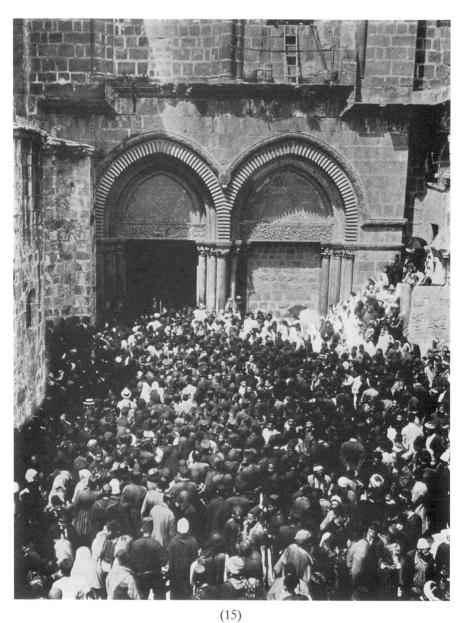

(15)
Elmendorf, *The Throng of Pilgrims and Others*, 1901,
from **A Camera Crusade Through the Holy Land**, private collection

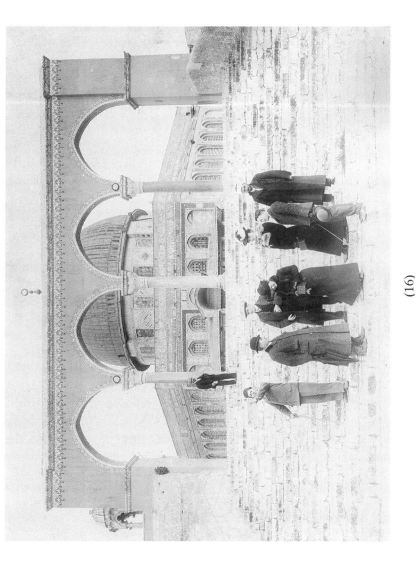

(16)

Unknown photographer, *European tourists at the steps of Qubat al sakhrah (Dome of the Rock)* end of the 19th century, Mohammed B. Alwan Collection

The third pattern mentioned above — the objectification of human figures as proof of biblical accounts — points to the fact that when people were included in the commercially distributed photographs, their inclusion was often intended as an illustration of Palestine's biblical heritage. Images of shepherds in the vast arid landscape of the mountains or of a few fishermen at the sea of Galilee were among the most popular photographs of this type. The choice to include human figures was often intended to invoke some particular biblical message. The image of the shepherds in the fields invokes the biblical story of the birth of Jesus; a woman getting water from a well invokes the scene of Jesus with the Samaritan woman; and women near the entrance of a cave recalls the scene of resurrection. Some photographers, like Dwight Elmendorf, went even further to list on the back of their photographs the particular biblical verses relevant to the depicted image.

An example of the objectification of Palestinians is the photograph taken by Bonfils in the 1870s of an old peasant man talking to an old peasant woman in a field of wheat. The caption described the scene as *The field of Boaz*. Elmendorf — who copied the same setting in a photo of an old peasant couple in a wheat field — went even further to describe the couple in his caption as *Ruth and Boaz*. This type of photographs was rather the norm when it came to the commercially distributed stereoscopic collections. In a stereoscope from the Keystone View Company, we see the plateau between al-Aqsa mosque and the Dome of the Rock filled with people. The caption for this card describes the scene as a "Mohammedan Pilgrims in Temple Area, Jerusalem." However, if we examine the back of the card, we get a better idea of the reason why Muslim pilgrims were photographed in the first place. Among other things, the text on the back states:

> This is a Mohammedans festival; but it may illustrate many events in Bible history. When, a little less than a thousand years before Christ, on that plateau arose the walls and pinnacles of Solomon's newly built temple, walked up those steps with songs and trumpets and harps, King Solomon, in royal robes and crown, leading the procession. When two centuries after Solomon, King Hezekiah held a great Passover and people came from all parts of the land, there was a congregation like this before us....

Not only did the immediate reality serve only to illustrate certain past events, but the information presented lacks historical accuracy. For the text also includes a quick reference to the Dome that appeared in the photograph stating that it was built in the tenth century after Christ, while in fact the Dome of the Rock dates further back to the end of the seventh century.

The process of turning Palestinian peasants into biblical icons had its counterpart in the genre of staged studio portraits, which became fashionable in the last two decades of the nineteenth century. The work of Tancrède R. Dumas — who was employed in the late 1870s by the American Palestine Exploration Society — is an example of this photographic genre. He photographed people, especially women, dressed in the different Palestinian traditional costumes. In his written identifications, his subjects were associated with towns and villages that had biblical connotations. An example of Dumas' captions are the two photographs, *A Woman From Bethlehem* and *A Man From Bethany*. However, it is rather hard to accept the authenticity of some of the featured characters fully. For in a number of cases, the subjects of the photographs appear to have been posing models. A good example of this can be found in the Bonfils' collection where the same person appears in two different photographs identified in one as a cotton carder and in the other as the chief rabbi of Jerusalem.[47] Similarly, in one of Dumas' photographs, the posing subject is identified as the Maronite patriarch of Jerusalem, an office which never existed. Notwithstanding the issue of authenticity, such photographs did not constitute an honest reflection of the country's population, for most of them featured members of the smallest minorities in Palestine, such as Samaritans, Armenians and Bedouins.

(17)

Underwood and Underwood, *Sheep and shepherd near Nablus*, 1900, private collection

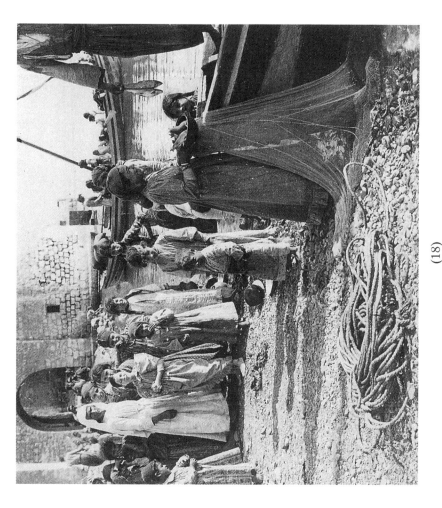

(18)

Underwood and Underwood, *Life on the shore of Galilee at Tiberias, Palestine*, 1900, private collection

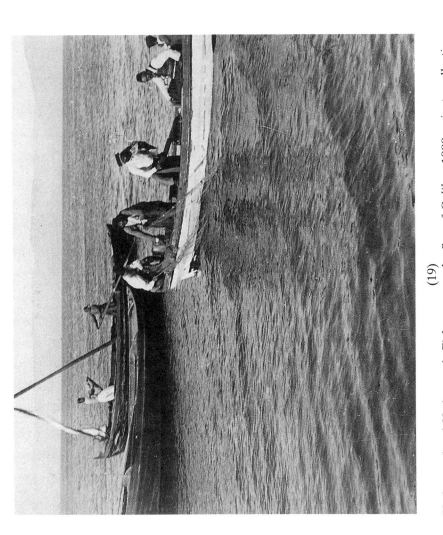

(19)

Underwood and Underwood, *Fishermen on the Sea of Galilee*, 1900, private collection

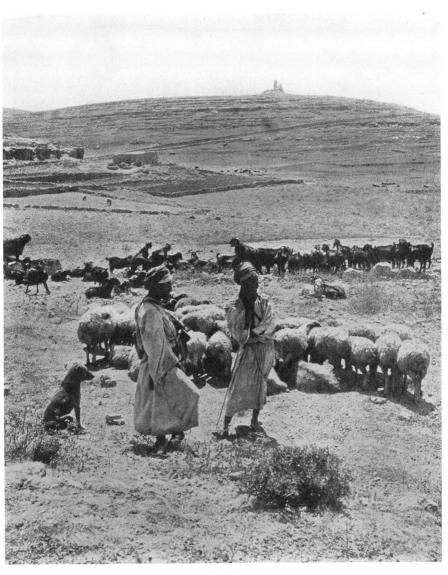

(20)
Elmendorf, *Shepherds and Sheep*, 1901, private collection

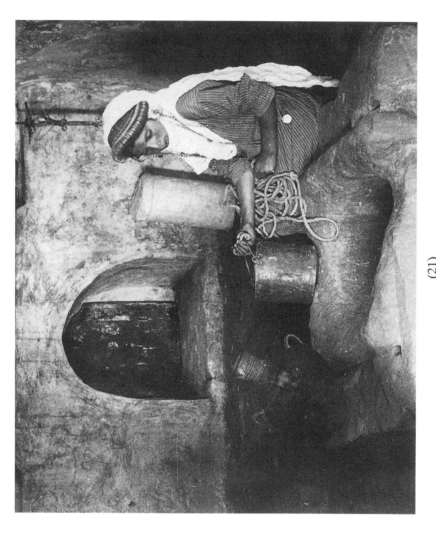

(21)

Underwood and Underwood, *A Samaritan Woman at Jacob's Well (Nablus)*, 1900, private collection

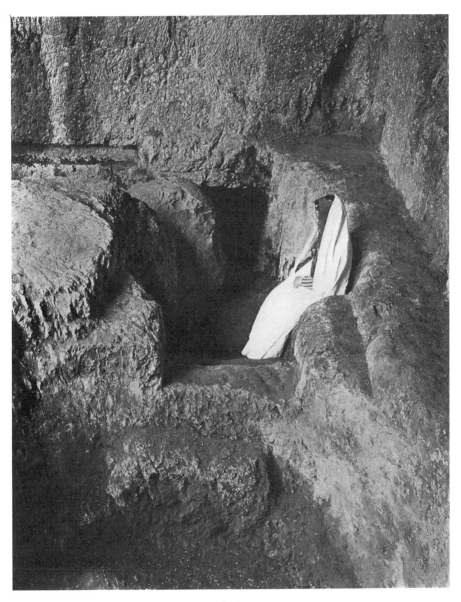

(22)
Elmendorf, *The Stone Rolled Away*, 1901, private collection
A re–enactment of the scene of resurrection

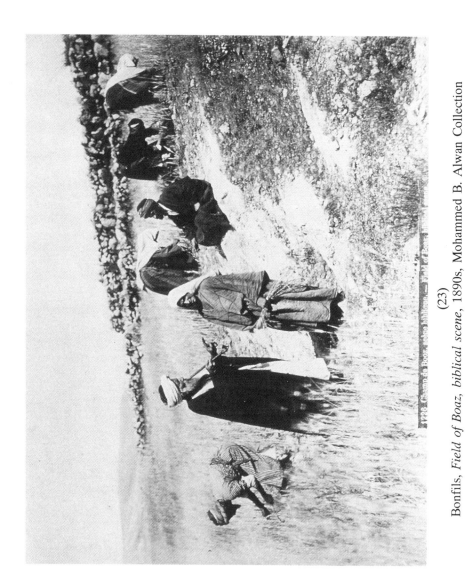

(23)

Bonfils, *Field of Boaz, biblical scene*, 1890s, Mohammed B. Alwan Collection

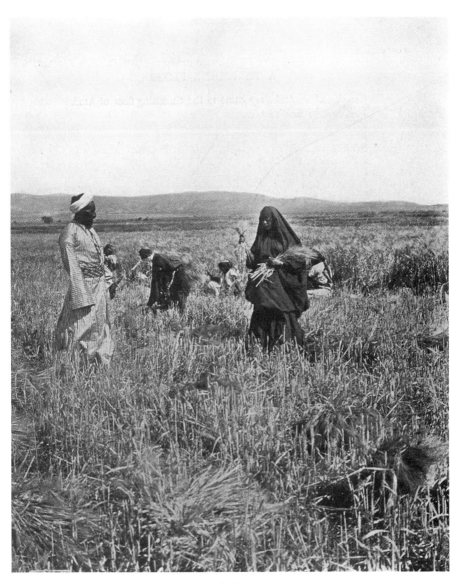

(24)
Elmendorf, *Ruth and Boaz*, 1901,
from **A Camera Crusade Through the Holy Land**

The objectification of Palestinian figures often occurred in conjunction with the fourth pattern listed above, namely, the staging of biblical scenes. It is sometimes difficult to determine whether some of the photographs were staged or were simply realistic scenes which the photographers' manipulation transformed into some sort of biblical allegorical image. This type of photographs was particularly popular among producers of stereoscopic images. In a stereoscopic card from the collection entitled *The Travel Lessons of Jesus*,[48] for instance, we see a man dressed as an Armenian monk, walking away from another man lying on the ground, while a third person dressed in a Palestinian peasant dress, having stepped down from his horse, helps the man on the ground. The caption reads *On The Road to Jericho: The Parable of the Good Samaritan*. This photograph is representative of a large number of similar situations staged to reflect biblical scenes. Among them, a large number of photographs show people with deformities, more specifically lepers, who invoke the biblical story of Jesus healing the lepers. However, the biblical image is not the only message at hand in the photographs of lepers which can be found in all the stereoscopic collections published on Palestine. The caption *Unclean Wretched Lepers Outside Jerusalem* appeared on the back of all such stereoscopes from *Underwood and Underwood*. The accompanying guide to the collection, *Jerusalem Through the Stereoscope* notes that "there are generally forty to fifty of them outside the city," adding that such a deadly "disease of sin" is hereditary for "every man inherits [it] from a line of sinning ancestors...which no human power can cure."[49] The text also suggests an attitude of superiority on the part of the European toward these "deformed, unclean and underdeveloped" inhabitants of the Holy Land.

Incidentally, the staging of biblical scenes was not limited to nineteenth-century photographic images but continued to appear all through the years of the British Mandate. In a photograph by the Swedish Eric Matson,[50] taken either in the 1920s or the 1930s and entitled the Judean home,[51] the exterior of a very old construction resembling a grotto can be seen. In it a father figure appears standing while a mother figure, holding a baby in her arms, is sitting on the ground. Another man and two camels can also be seen in the photograph. The resemblance between this picture and that of the Nativity scene can hardly be a coincidence.

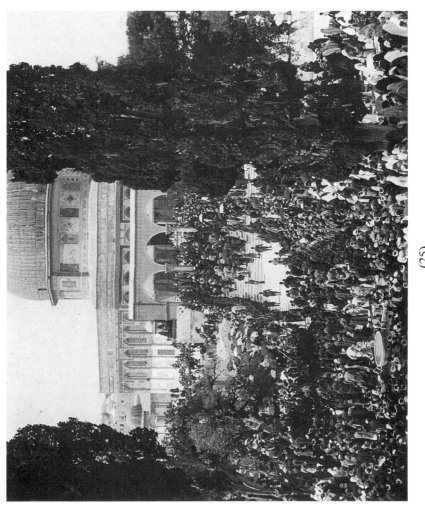

Keystone Stereoscope, *Mohammedan pilgrims*, around 1900, private collection

(25)

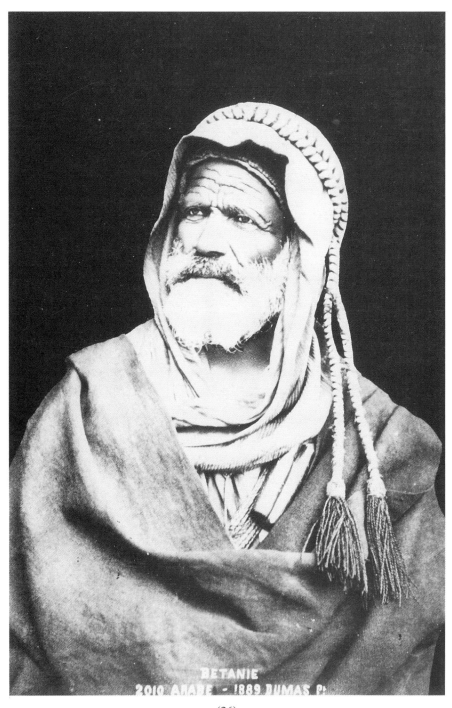

(26)

Dumas, *An Arab from Bethany*, 1889, Mohammed B. Alwan Collection

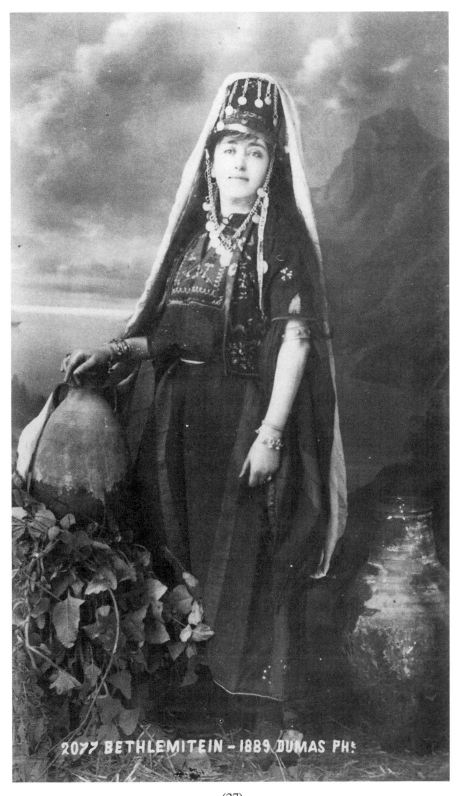

(27)

Dumas, *A Woman from Bethlehem*, 1889, Mohammed B. Alwan Collection

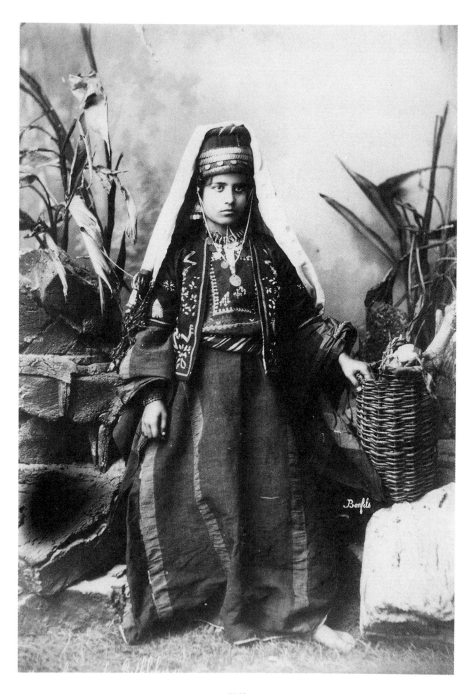

(28)
Bonfils, *Woman from Bethlehem* (studio portrait), Mohammed B. Alwan Collection

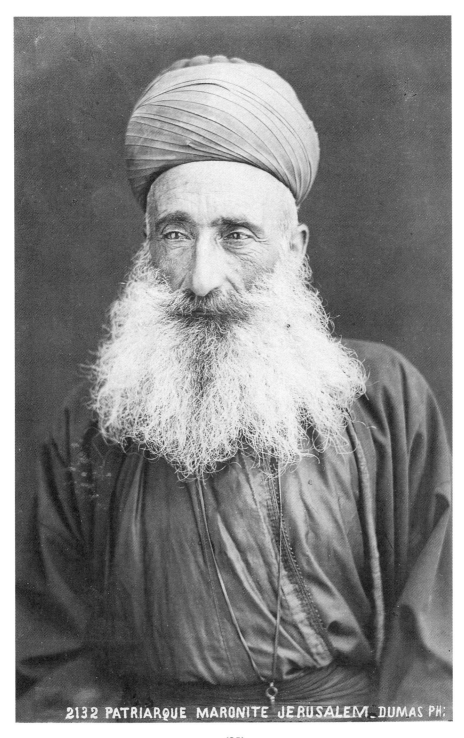

2132 PATRIARQUE MARONITE JERUSALEM. DUMAS PH:

(29)
Dumas, *Maronite Patriarch of Jerusalem*, 1880s,
Mohammed B. Alwan Collection

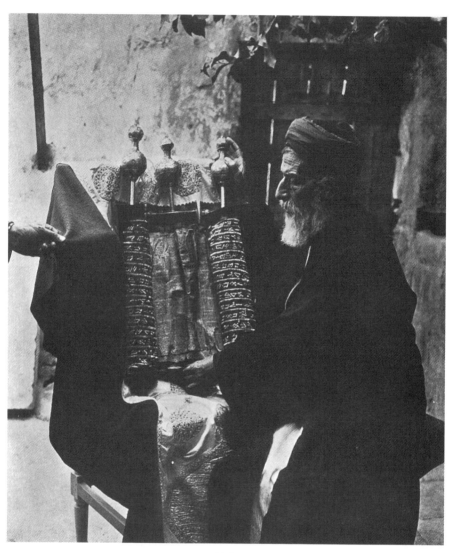

(30)
Elmendorf, Samaritan with scrolls, 1901, private collection

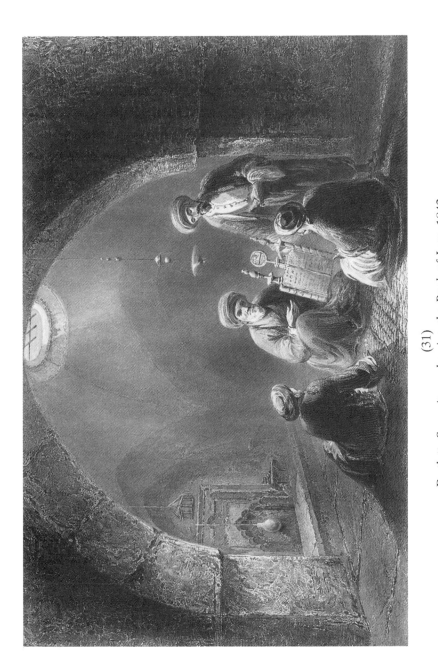

(31)

Bartlett, *Samaritans showing the Book of Law,* 1842,
from Henry Stebbing's **The Christian in Palestine** (1847)

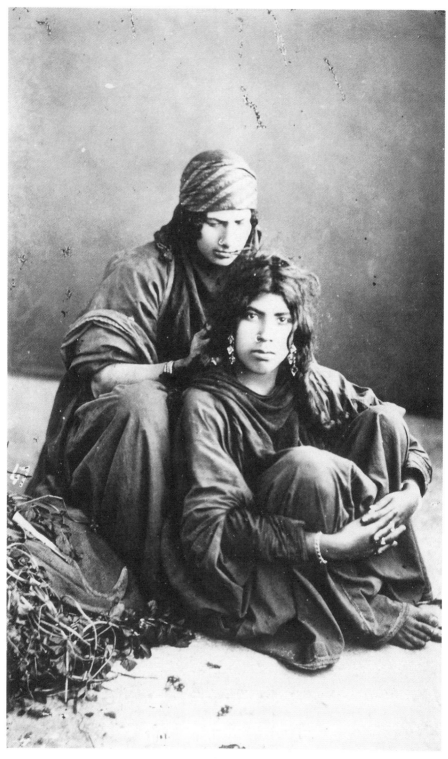

(32)
Dumas, *Bedouins from Jericho*, Mohammed B. Alwan Collection

The fifth pattern acquires its significance from its absence. It is almost impossible to find any nineteenth-century photographs of Jerusalem that correspond to the image of the exotic Orient — at least not to the image presented in Orientalist art of the period, as illustrated by Gérôme's *The Snake Charmer*. If the image of the East as the *Exotic Other* was as popular as travel logs, romantic poetry and paintings indicate it was at the turn of the twentieth century, why was this image absent from the photography of Jerusalem? The question becomes more pressing if we take into consideration that, in fact, it was fashionable among European photographers of the East, including some of the same photographers who visited Jerusalem, to take photographs of nude women in other places (often identified as Algerian, Nubian, Moorish or Bedouin). While this could be taken to suggest a desire on the part of the photographers to respect the sanctity of the city of Jesus, its religious ceremonies and clergy, the absence of this genre of photographs could also indicate that in the mind of European photographers, Jerusalem was not a location that belonged together with the rest of the Orient. Rather, it was a familiar site, very well known to the Europeans and often claimed by them. It is interesting to notice in this respect, that photographs of nude women were not totally absent from the photography of the rest of Palestine. In the Bonfils collection, for example, there are at least two different photographs that show a woman carrying a bundle of wood on her head with one of her breasts exposed.[52] In the catalog of Bonfils photographs, one of these photographs is described as a Bedouin from Jericho. It is also interesting to note the resemblance between this and another photograph, almost identical, taken by Tancrède Dumas around the same time. In this photograph we also see a standing woman holding a bundle of wood with her breast exposed. Dumas entitled this photograph *a Bedouin from Beirut*. The similarity between the two images could easily be seen in the context of the next pattern.

The last pattern we would like to discuss, then, is represented by numerous photographs of the exact same locations, taken from the exact same angle, even when the sites had no apparent special significance. Several photographs taken by Bonfils and by the photographers of the American Colony (among others) show the same scene which they labeled *First Site of Jerusalem*. Not only do all these photographs depict the same site from the same angle, but they even show a similar number of animals and people in the same

location. This replication indicates that what we have at hand is more than a simple case of new photographers following the lead of the earlier ones. The extent of such duplication reveals that a photographic tradition was already established in the minds of the photographers which they felt obligated to follow. It was as if any site previously photographed in the city had acquired some meaning that every new photographer felt obligated to document.

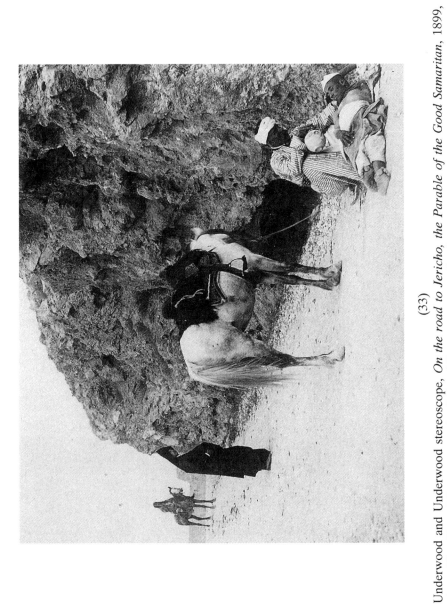

(33)

Underwood and Underwood stereoscope, *On the road to Jericho, the Parable of the Good Samaritan*, 1899, from **The Travel Lessons on the Life of Jesus**, private collection

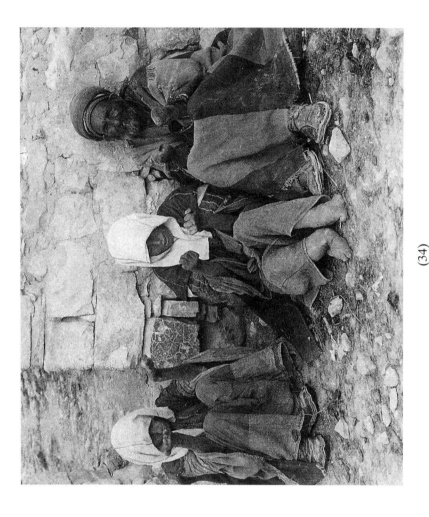

(34)

Underwood and Underwood stereoscope, *"Unclean! Unclean!" Wretched lepers outside Jerusalem*, 1897, from **The Travel Lessons on the Life of Jesus**, private collection

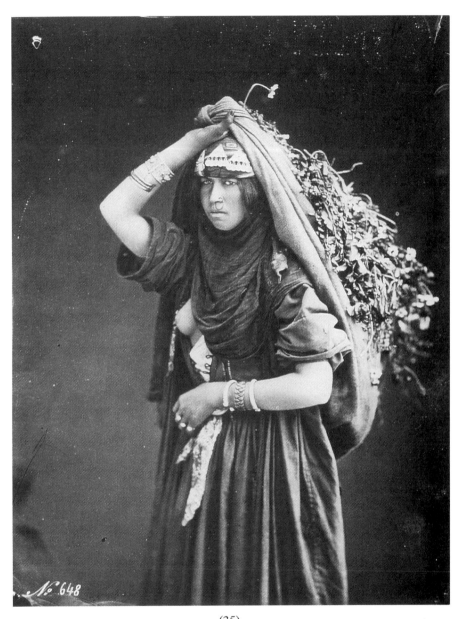

(35)

Bonfils, *A Bedouin from Jericho in Jerusalem*, Mohammed B. Alwan Collection

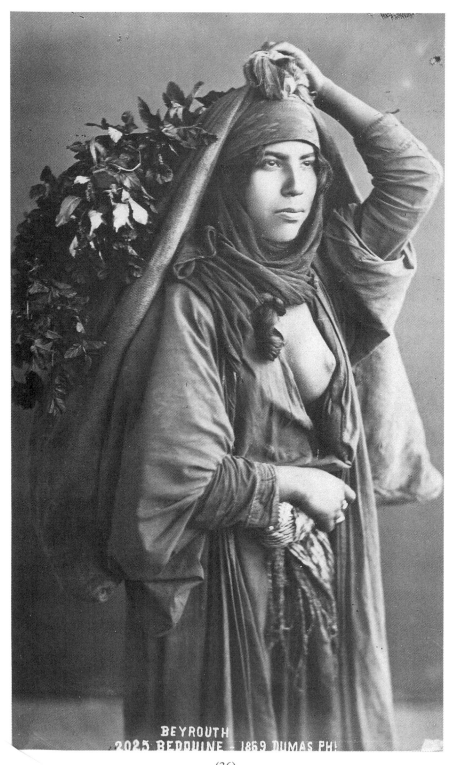

(36)

Dumas, *A Bedouin from Beirut*, 1869, Mohammed B. Alwan Collection

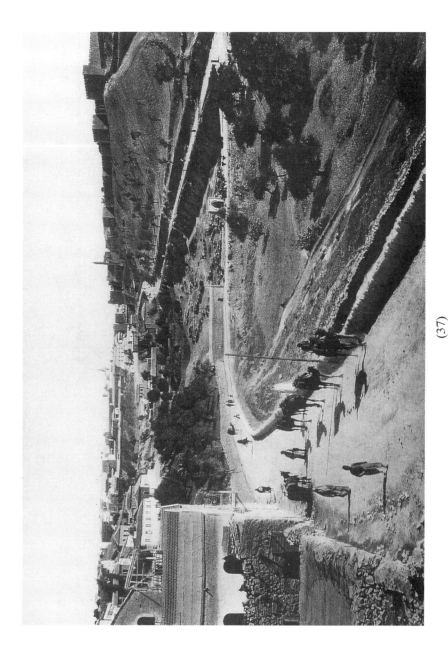

(37)

Photographer unknown, *First view of Jerusalem*, 1890s, private collection

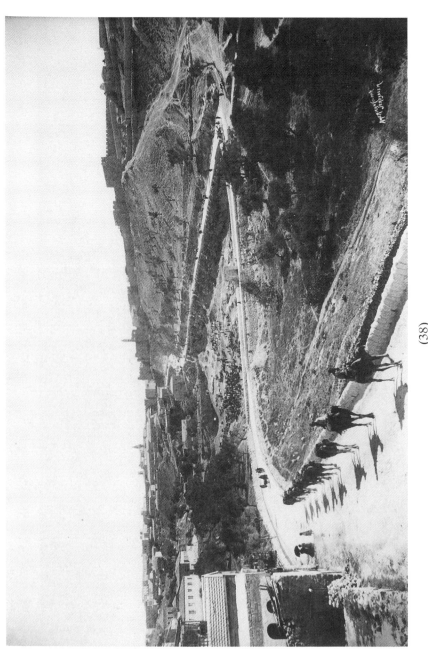

(38)

American Colony, *The first view of Jerusalem*, 1900, Mohammed B. Alwan Collection

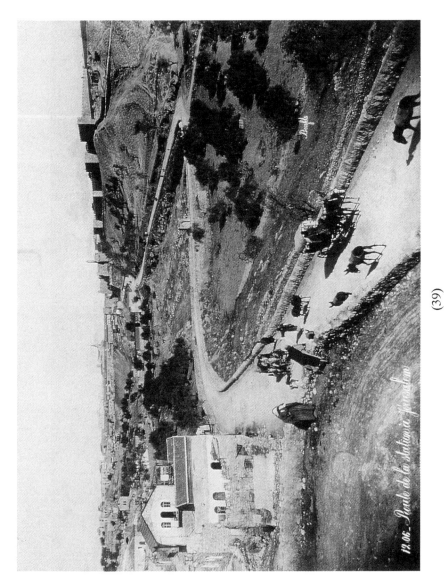

12.06. Route de la Station à Jérusalem

(39)

Bonfils, *Route from the Station to Jerusalem*, 1880s, Mohammed B. Alwan Collection

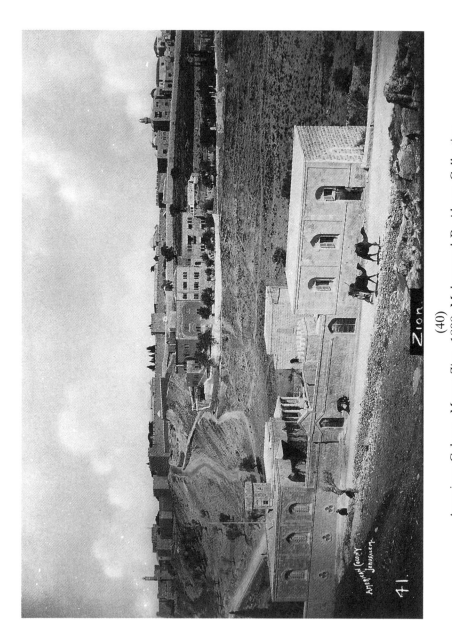

(40)

American Colony, *Mount Zion*, 1898, Mohammed B. Alwan Collection

IN THE SERVICE OF COLONIALISM

The point needs to be reiterated that there is "no such thing as one, definitive meaning of a text or image."[53] Rather different possible meanings originate from different readings of the same text or image which are very much dependent upon the particular experiences of the readers/viewers and the historical and cultural contexts in which they are being constructed. However, it is important to emphasize that photographers are not always fully aware of all the possible meanings for the images they produce. For they are subject to various kinds of unconscious processes through which connections with previously existing concepts and ideas are formulated.[54] The market demand for certain kinds of images of Jerusalem coupled with their dissemination through publications and exhibitions only confirms that an authoritative popular view of Jerusalem was in existence both in Europe and in America. In this sense, nineteenth-century photography of Palestine was not only about representing the country's landscape; it also revealed something very significant about the way in which Europeans thought of themselves and of the world around them at that particular time in history. The images presented in the photographs corresponded to the popular image of Palestine as the Holy Land, at least in the same sense that the travel literature presented it at the time. They also paralleled the general attitude of the colonial European powers towards Palestine.

For the European powers, the British and French in particular, the nineteenth century was a century of discovery during which they extended their economic, political, and cultural hegemony over most of the non-industrialized world.[55] In the case of Palestine, this paradigm of European colonial expansionism was further complicated by the special connection of the country to the biblical history of both Christianity and Judaism. This connection was fully exploited to serve European colonial expansionism. Calls for a "Peaceful Crusade" to establish a European Christian enclave in the Holy Land began to emerge in Europe after the Egyptian conquest in the 1830s. In this context, the different European powers competed among each other to pronounce themselves the protectors of the different Christian communities in Palestine, a role that further enabled them to expand their presence in the city. Russia pronounced itself the protector of the Christian Orthodox community; France assumed the same role for the newly re-established Latin Church; and Britain —

given the fact that there was no Anglican congregation — chose to present itself as the protector of the Jewish community.

In the case of Palestine, photography reflected — whether consciously or unconsciously — the European colonial desire for the political possession of Jerusalem. It continued the long tradition of presenting Jerusalem as the divine heritage that the European longed to possess which had dominated in European literature throughout the middle ages. Photography presented Palestine as a biblical site most relevant to Europe; it highlighted the presence of minorities (Christian or Jewish) who might have needed protection and who had close ties with Europe, and presented the rest of the inhabitants as masses of backward uncivilized individuals. The images that invaded the European and American homes contributed to the shaping in the mind of the Europeans of an image of Palestine as a dream land, to use Doumani's words, "waiting to be reclaimed both spiritually and physically."[56]

NOTES

1. Stephen Kern, *The Culture of Time and Space* (Cambridge MA: Harvard University Press, 1983), 39.

2. *Ibid.*, 38.

3. Oliver Wendell Holmes (1809-1894) was an amateur photographer, poet and professor at the Harvard Medical School. He used this term to refer to photography in his article "The Stereoscope and the Stereograph," in Alan Trachtenberg, *Classic Essays on Photography* (New Haven: Leete's Island Books, 1980), 71-82.

4. Sarah Graham-Brown, *Images of Women* (New York: Columbia University Press, 1988), 3.

5. Susan Sontag, *On Photography* (New York: Farrar, Strauss and Giroux, 1977), 3.

6. Robert L. Tignor's introduction to *Napoleon in Egypt: Al-Jabarti's Chronicle of the French Occupation, 1798*, translated by Shmuel Moreh (Princeton and New York: Markus Wiener Publishing, 1995), 12.

7. B. McGrane, *Beyond Anthropology: Society and the Other* (New York: Columbia University Press, 1989), 94.

8. Paul E. Chevedden, *The Photographic Heritage of the Middle East: An Exhibition of Early Photographs of Egypt, Palestine, Syria, Turkey, Greece, & Iran, 1849-1893* (Malibu: Undena Publications, 1981), 1.

9. See *Remembrance of the Near East: The Photographs of Bonfils, 1867-1907*, catalog for the exhibition of Bonfils Photographs at the International Museum of Photography at George Eastman House from May 23-September 1, 1980. No page numbers provided.

10. Edward Said, *Orientalism* (New York: Vintage Books, 1979), 101.

11. Gérard de Nerval, *Oeuvres*, ed. Albert Béguin and Jean Richet (Paris: Gallimard, 1960), 1: 933, quoted in Edward Said, *Orientalism*, 100.

12. This painting — which has often been referred to as a classical visual example of the 19th-century colonialist ideology — was used by Edward Said for the cover of *Orientalism.*

13. Linda Nochlin, "The Imaginary Orient," in *Art in America* (May 1983), 119.

14. *Ibid.*, 119.

15. Donald Rosenthal, *Orientalism: The Near East in French Painting 1800-1880* (Rochester, New York: Memorial Art Gallery of the University of Rochester, 1982), 120.

16. Although this album was Du Camp's only photographic work, it made him famous.

17. Naomi Sheperd, *The Zealous Intruders: The Western Rediscovery of Palestine* (San Francisco: Harper & Row, Publishers),77.

18. Dwight Elmendorf, *A Camera Crusade Through The Holy Land* (New York: Charles Scribner's Sons, 1912), vii.

19. Francis Frith, "Photographic Contributions to Knowledge: Egypt and Palestine," *The British Journal of Photography* (February 1, 1860): 32.

20. John Cramb, "Palestine in 1860; Or, A Photographer's Journal of a Visit to Jerusalem," *The British Journal of Photography* (December 2, 1861): 425.

21. "Architectural Photographic Exhibition," *The British Journal of Photography* (March 15, 1860), 88.

22. *Ibid.*, 88.

23. Reinhold Rohricht, *Bibliotheca Geographica Palestinae* (London: John Trotter Reprints, 1989), 338-597.

24. Nissan N. Perez, *Focus East: Early Photography in the Near East (1839-1885)* (New York: Harry N. Abrams, Inc., Publishers, 1988), 124-233.

25. The present study will be confined to photographs taken by professional photographers, for they were more widely accessible to the general public — both in the Near East and in Europe — and can be considered, in turn, the product of a market demand for Holy Land images. As such they illustrate more clearly the type of photographs that were sought by the public.

26. Paul E. Chevedden, *The Photographic Heritage of the Middle East* (Malibu, Undena Publications, 1981), 1.

27. Abigail Solomon-Gordeau, "A Photographer in Jerusalem, 1855: Auguste Salzmann and His Times," *October*, 18 (Fall 1981): 91-107.

28. For more information on Louis de Clercq, see Paul E. Chevedden, *The Photographic Heritage of the Middle East*, 1-2.

29. *Ibid.*, 6.

30. Nissan N. Perez, *Focus East: Early Photography in the Near East (1839-1885)*,171.

31. See Carney E. S. Cavin, *The Image of the East* (Chicago and London: The University of Chicago Press, 1982), 17-37.

32. Nissan N. Perez described Tancrède R. Dumas as being of Italian origin. See *Focus East: Early Photography in the Near East (1839-1885)*, 160.

33. *Ibid.*, 124.

34. *Ibid.*, 163.

35. *Ibid.*, 233.

36. Paul E. Chevedden, *The Photographic Heritage of the Middle East*, 3.

37. For more information see Dan Kyram, "Early Stereoscopic Photography in Palestine," *History of Photography* (Autumn 1995): 228-230.

38. For more information see Nissan N. Perez, *Focus East: Early Photography in the Near East (1839-1885)*, 169.

39. Graham's photograph belongs to the collection of the Palestine Exploration Fund in London (PEF p2159).

40. Phillips accompanied the Palestine Exploration Fund's archaeological mission that went to Palestine in 1867. He has been mentioned often as the first photographer to take ethnographic photographs in Palestine.

41. Dwight Elmendorf, *A Camera Crusade Through The Holy Land*, plate LXXVIII.

42. An early photographic process developed by Talbot that required a long exposure time.

43. Edward L. Wilson, *In Scripture Lands*, 265, quoted in John Davis, *The Landscape of Belief* (Princeton: Princeton University Press, 1996), 87.

44. John Cramb, "Palestine in 1860; Or, A Photographer's Journal of a Visit to Jerusalem," *The British Journal of Photography* No. X (November 1, 1861): 388.

45. Yeshayahu Nir, *The Bible and the Image* (Philadelphia: University of Pennsylvania Press, 1985), 135.

46. Beshara Doumani, "Rediscovering Ottoman Palestine: Writing Palestinians into History," *Journal of Palestine Studies*, XXI, no. 2 (Winter 1992): 7.

47. In the Bonfils photographic collection of the Harvard Semitic Museum (HSM) these two photographs were classified as 4E1 and 4E2. See Carney E. S. Gavin, *The Image of the East* (Chicago and London: The University of Chicago Press, 1982), 78.

48. This collection was designed and its text authored by Rev. William Byron Forbush and distributed by Underwood and Underwood publishers in the 1890s.

49. Jesse Lyman Hurlbut, *Jerusalem Through the Stereoscope* (New York: Underwood and Underwood, 1908), 91.

50. This photograph does not represent the core of the photographic work of Eric Matson. He was the photographer of the American Colony in Jerusalem and his

large collection, housed at the Library of Congress, fully documented the Near East, its geography and its people.

51. Sarah Graham-Brown, *Palestinians and their Society 1880-1946* (NY: Quartet Books, 1980), 1.

52. Photographs 4F4 and 4F9 in the HSM collection. See Carney E. S. Gavin, *The Image of the East*, 79.

53. Felicity Edhom, "Beyond The Mirror: Women's Self Portraits," in *Imagining Women: Cultural Representations and Gender*, edited by F. Bonner, L. Goodman, R. Allen, L. Jones and C. King (Cambridge MA: Polity Press in association with The Open University, 1992), 158.

54. *Ibid.*, 158.

55. Beshara Doumani, "Rediscovering Ottoman Palestine: Writing Palestinians into History," 7.

56. *Ibid.*, 7.

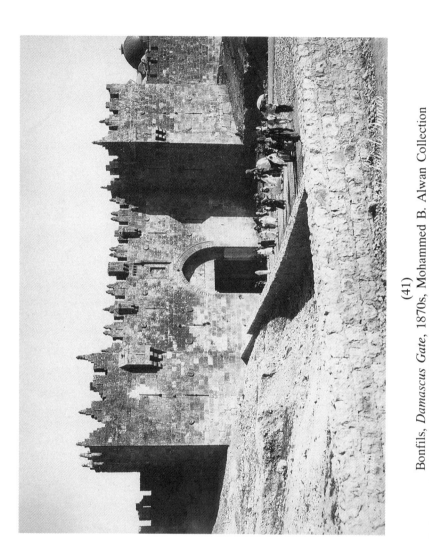

(41)

Bonfils, *Damascus Gate*, 1870s, Mohammed B. Alwan Collection

Although the gate had been rebuilt by Suleiman the Magnificent, it retained its original shape. It is the most elaborate gate, known in Arabic as *Bab el–Amud* (Gate of the Column).

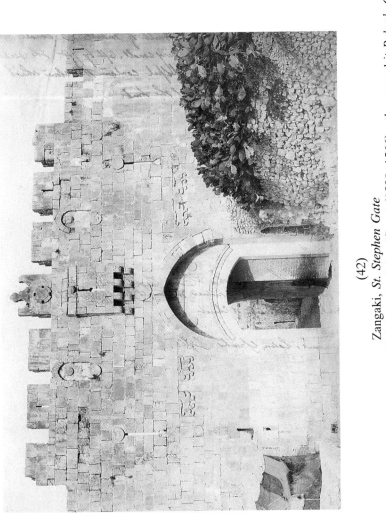

(42)

Zangaki, *St. Stephen Gate*

This gate was built during the reign of Suleiman the Magnificent (1520–1566), who named it *Bab el–Ghor* (the Jordan Valley Gate). Nowadays, it is better known as *Bab al–Asbat* (the Gate of the Tribes of Israel), in Arabic, or as Lions Gate, in Hebrew. Europeans, however, have kept the older name of the gate, namely, St. Stephen Gate, since the period following the fall of the Latin Kingdom in 1187.

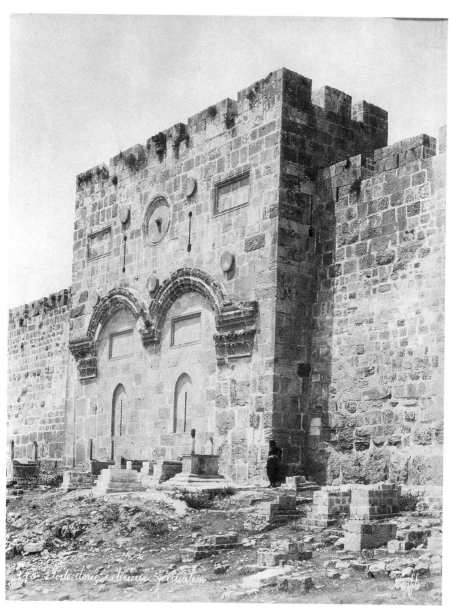

(43)
Bonfils, *The Golden Gate on the east side of the Haram area*,
Mohammed B. Alwan Collection

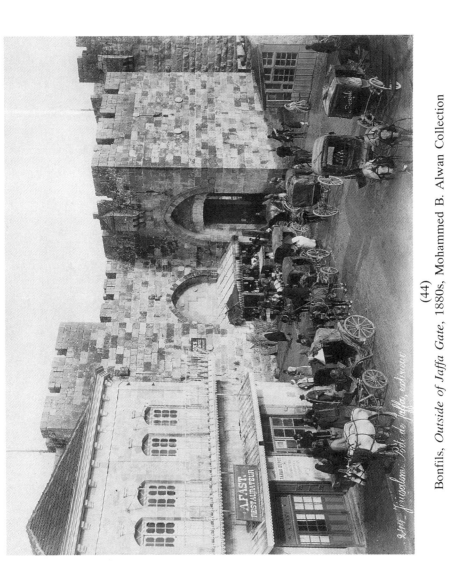

Bonfils, *Outside of Jaffa Gate*, 1880s, Mohammed B. Alwan Collection

(44)

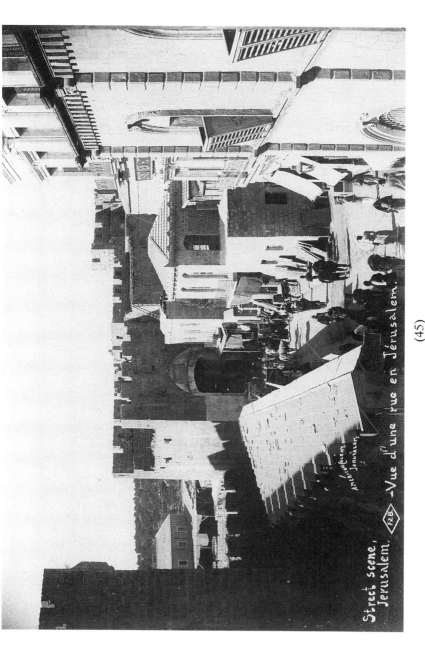

(45)

American Colony, *Jaffa Gate from the Inside*, 1890s, Mohammed B. Alwan Collection

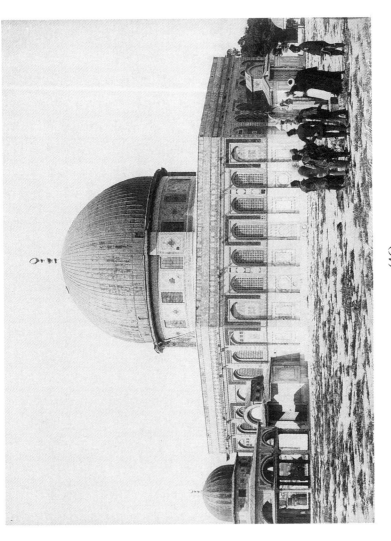

Zangaki 1051

Zangaki, *Dome of the Rock*, 1880s. Mohammed B. Alwan Collection

A group of Muslims getting water out of a well, on the northeastern side of the Dome of the Rock.

(46)

American Colony 232

American Colony, *Solomon's Stables*, around 1900, Mohammed B. Alwan Collection

This underground construction in *al–Haram esh–Sharif* platform has nothing to do with Solomon. It was used as a mosque during the Umayyad period (661–750), but its walls might have been built in the Herodian period (37–4 BCE). During the Crusaders period it was used as a stable for the horses by the Templars. It is currently under construction and is due to reopen as a mosque.

(47)

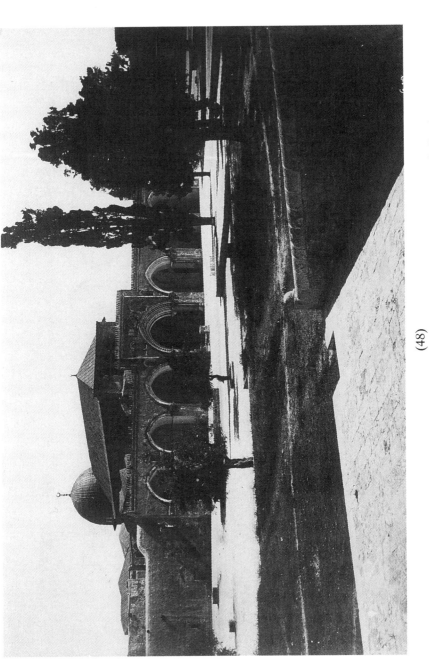

(48)

American Colony, *Al–Aqsa Mosque*, around 1900, Mohammed B. Alwan Collection

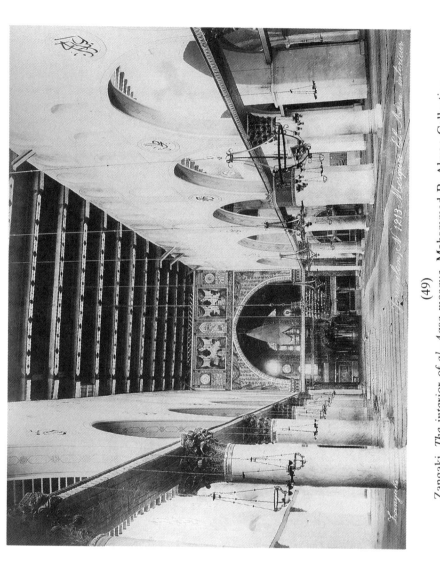

(49)

Zangaki, *The interior of al–Aqsa mosque,* Mohammed B. Alwan Collection

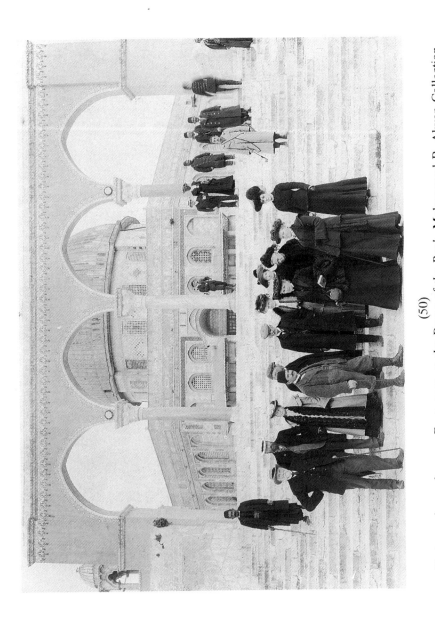

(50)

Photographer unknown, *Europeans at the Dome of the Rock*, Mohammed B. Alwan Collection
A group of European visitors in front of the Dome of the Rock. Ottoman guards can be seen in the back.

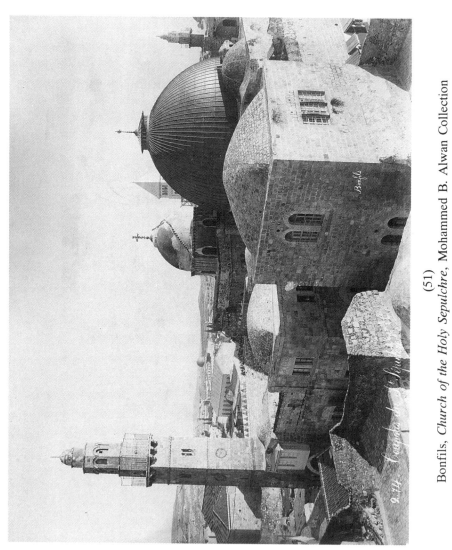

(51)

Bonfils, *Church of the Holy Sepulchre*, Mohammed B. Alwan Collection

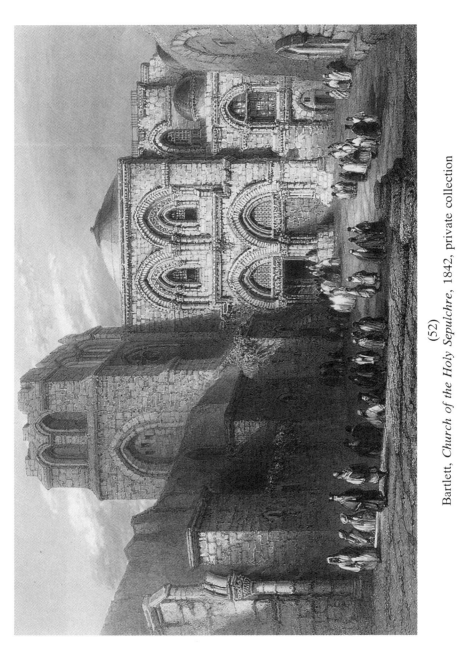

(52)

Bartlett, *Church of the Holy Sepulchre*, 1842, private collection

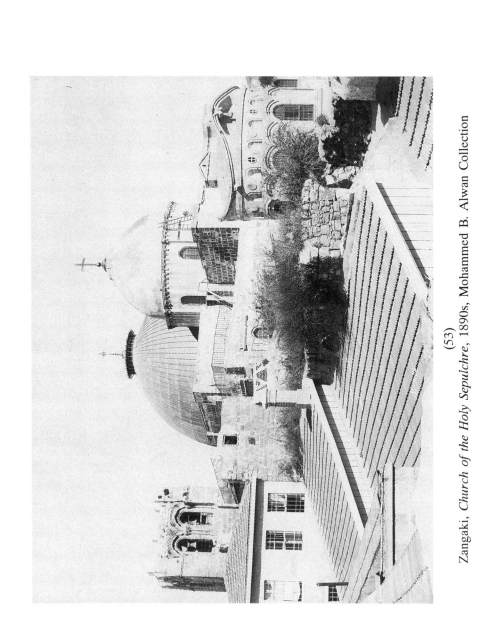

(53)

Zangaki, *Church of the Holy Sepulchre*, 1890s, Mohammed B. Alwan Collection

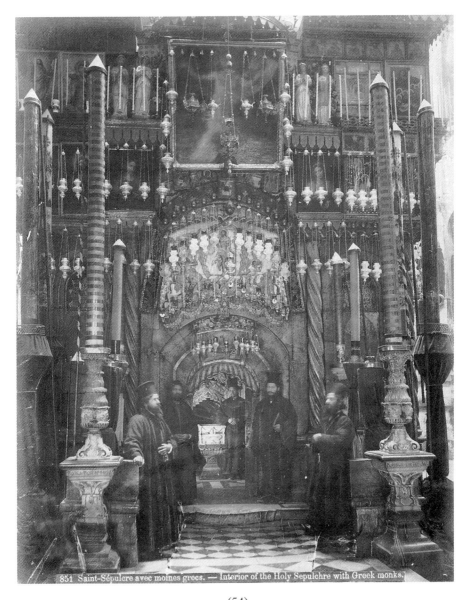

851 Saint-Sépulcre avec moines grecs. — Interior of the Holy Sepulchre with Greek monks.

(54)
Bonfils, *Greek Orthodox monks standing in front of the tomb inside the Church of the Holy Sepulchre*, Mohammed B. Alwan Collection

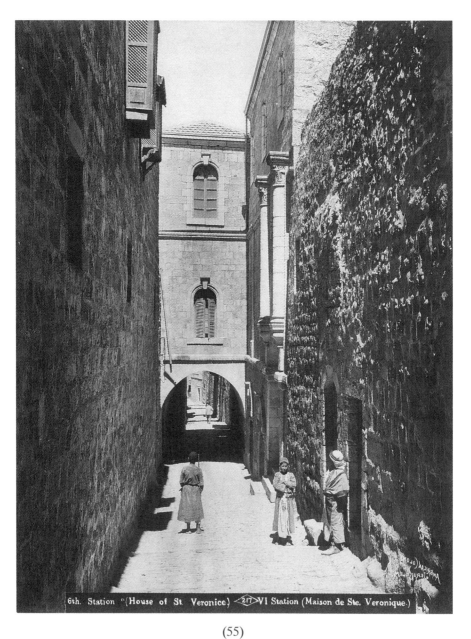

6th. Station "(House of St. Veronice) ◁217▷VI Station (Maison de Ste. Veronique)

(55)
American Colony, *Sixth Station on Via Dolorosa*, 1898, Mohammed B. Alwan
Collection

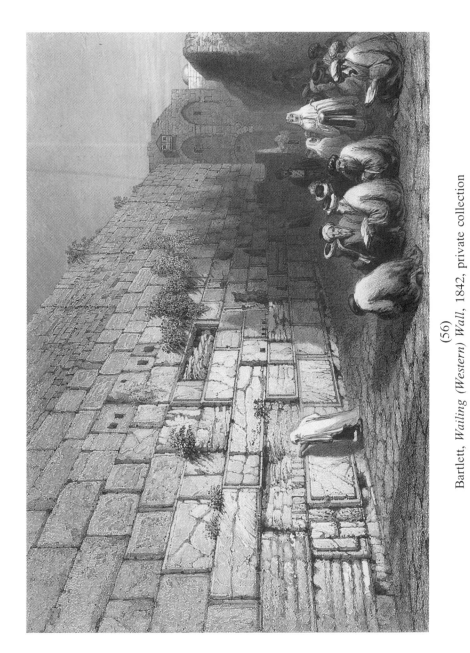

(56)

Bartlett, *Wailing (Western) Wall*, 1842, private collection

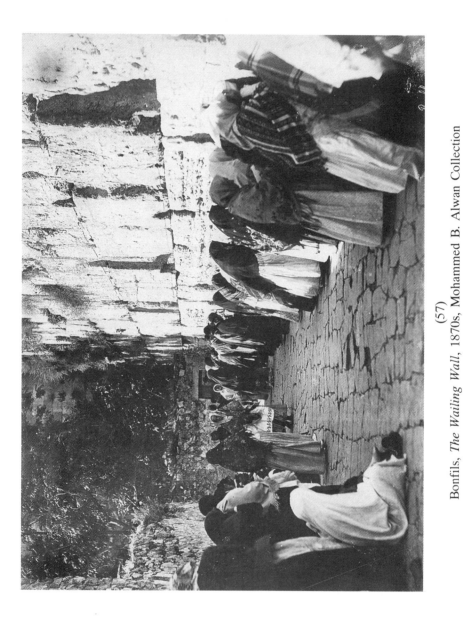

(57)

Bonfils, *The Wailing Wall*, 1870s, Mohammed B. Alwan Collection

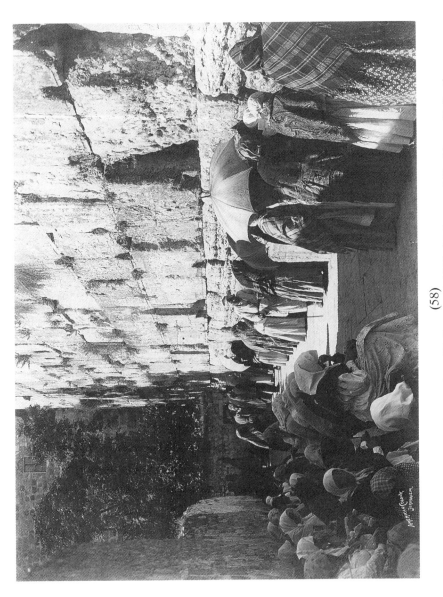

(58)

American Colony, *The Wailing Wall*, around 1900, Mohammed B. Alwan Collection

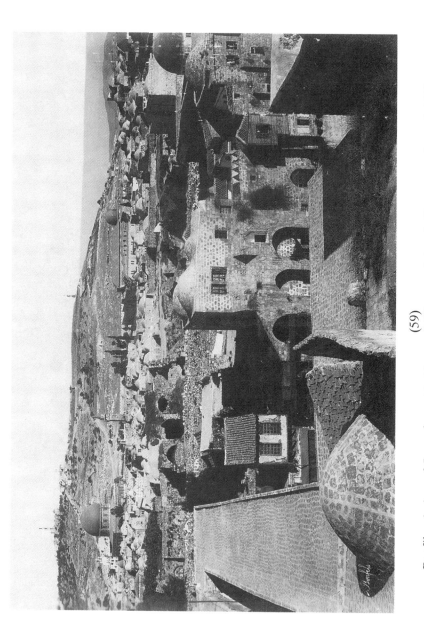

(59)

Bonfils, *A view of Jerusalem with Mount of Olives and the al–Haram es–shareef*, 1890s,
Mohammed B. Alwan Collection

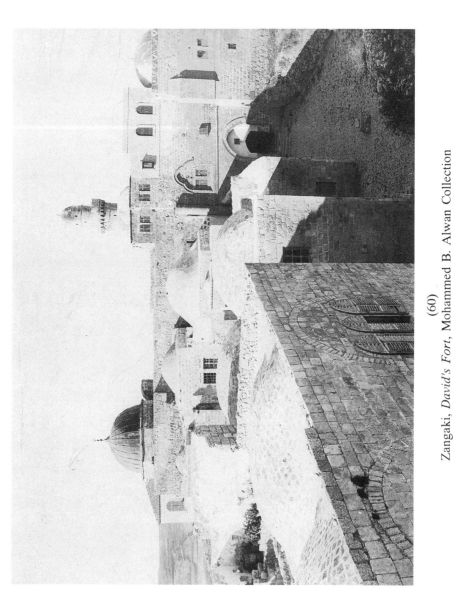

(60)

Zangaki, *David's Fort*, Mohammed B. Alwan Collection

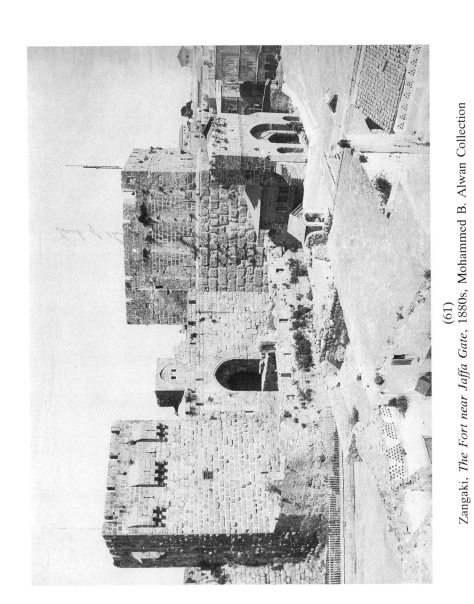

(61)

Zangaki, *The Fort near Jaffa Gate*, 1880s, Mohammed B. Alwan Collection

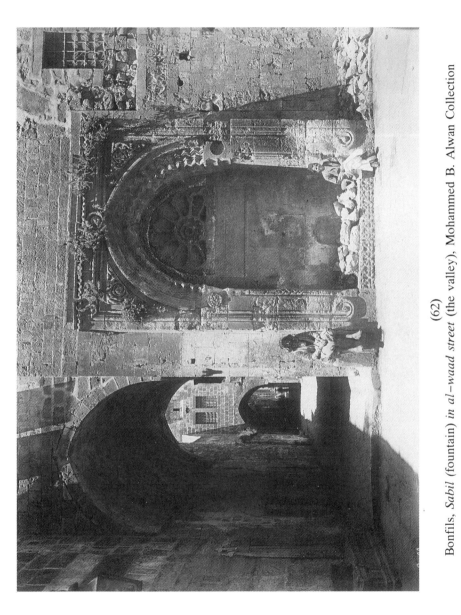

Bonfils, *Sabil* (fountain) *in al–waad street* (the valley), Mohammed B. Alwan Collection

(62)

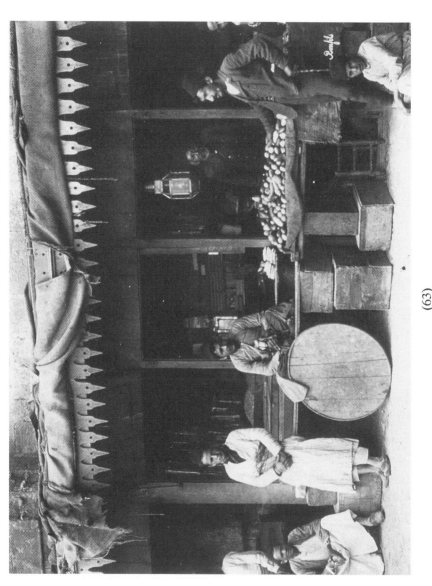

Bonfils, *Merchants near Jaffa Gate*, 1890s, Mohammed B. Alwan Collection

(63)

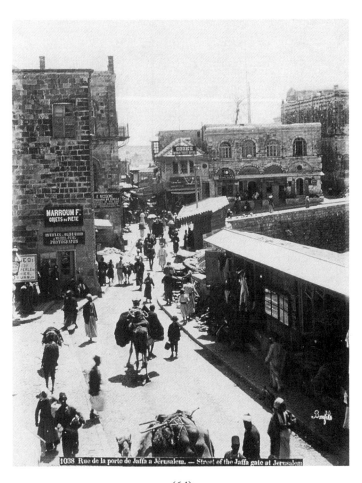

(64)
Bonfils, *Street leading to the Jaffa Gate in the Old City*, 1880s,
Mohammed B. Alwan Collection

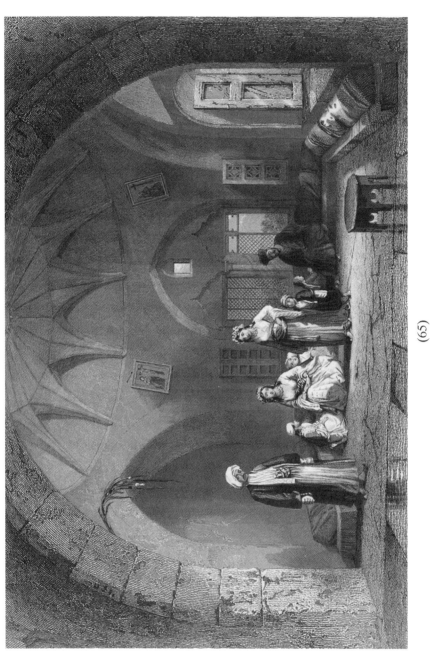

(65)

Bartlett, *Interior of the house of a Christian family in Jerusalem*, 1842, private collection

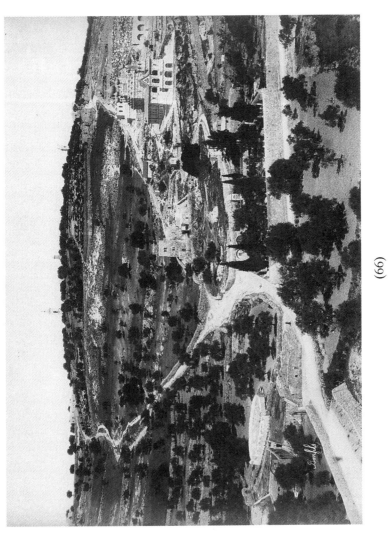

Bonfils 292 Bonfils, *A view of the Mount of Olives*, 1890, Mohammed B. Alwan Collection

This general view shows the Garden of Gesthemane and the Russian Church of St. Mary Magdalene, which was built by Czar Alexander III in 1885–1888.

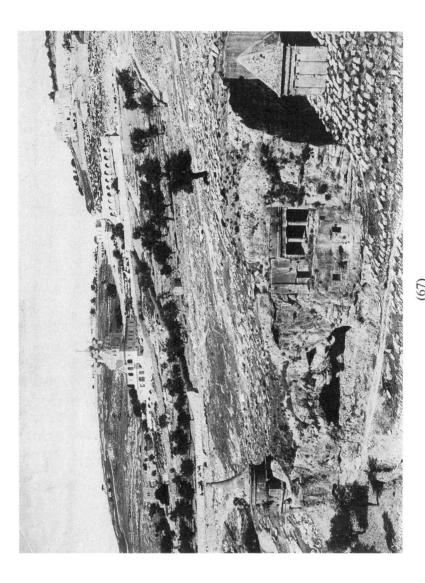

(67)

Zangaki, Tombs in the Kidron Valley (Absalom, Zachariah and Pharaoh's daughter) and Mount of Olives, 1890s, Mohammed B. Alwan Collection

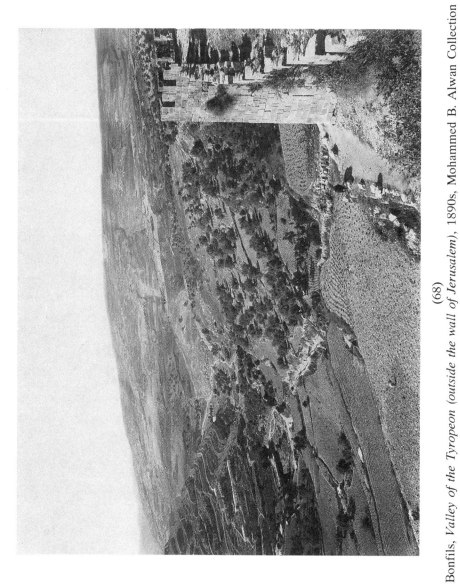

(68)

Bonfils, *Valley of the Tyropeon (outside the wall of Jerusalem)*, 1890s, Mohammed B. Alwan Collection

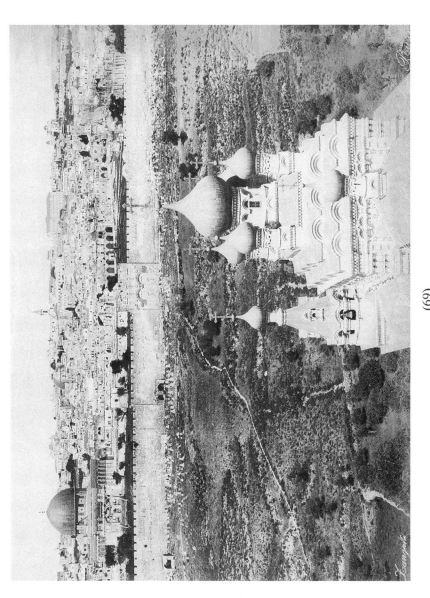

(69)

Zangaki, *Jerusalem from Mount of Olives*, 1890s, Mohammed B. Alwan Collection

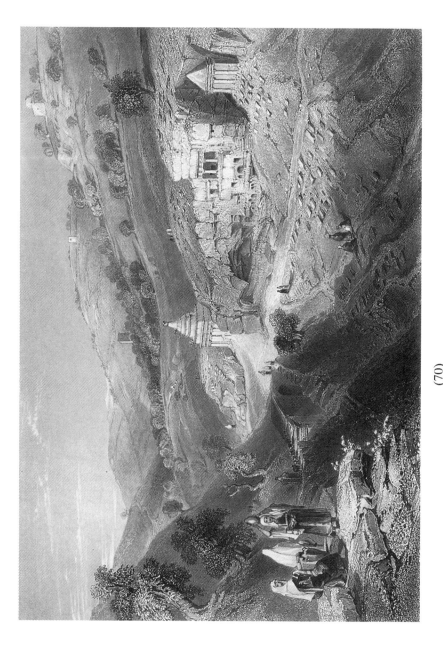

(70)

Bartlett, *Tombs in the Valley of Jehoshaphat*, 1842, private collection

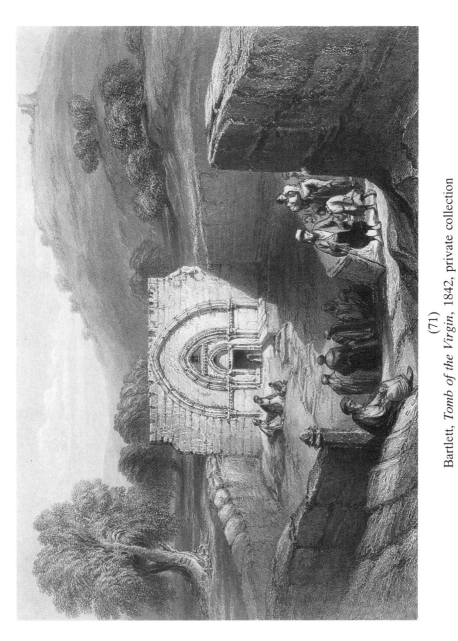

(71)

Bartlett, *Tomb of the Virgin*, 1842, private collection

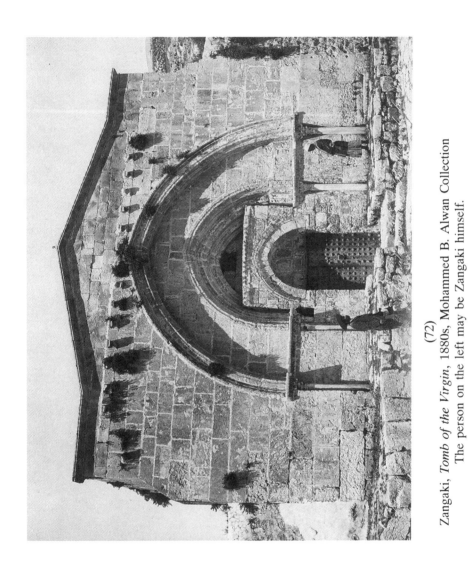

(72)

Zangaki, *Tomb of the Virgin*, 1880s, Mohammed B. Alwan Collection
The person on the left may be Zangaki himself.

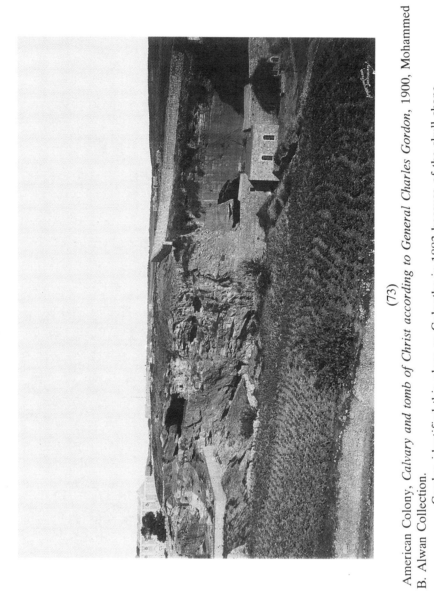

(73)

American Colony, *Calvary and tomb of Christ according to General Charles Gordon*, 1900, Mohammed B. Alwan Collection.

Gordon identified this place as Golgotha in 1883 because of the skull shape of the hill behind the tomb.

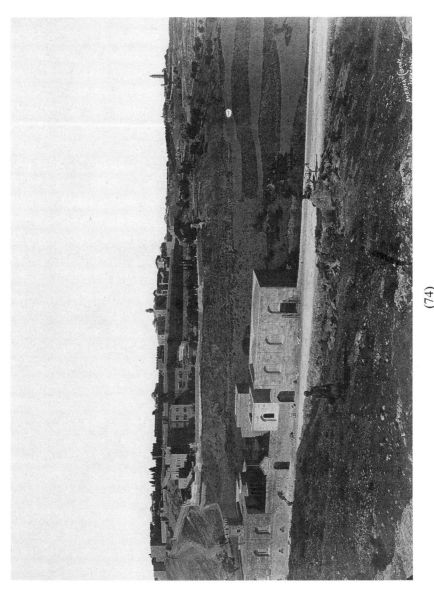

(74)

American Colony, *Mount Zion*, 1898, Mohammed B. Alwan Collection

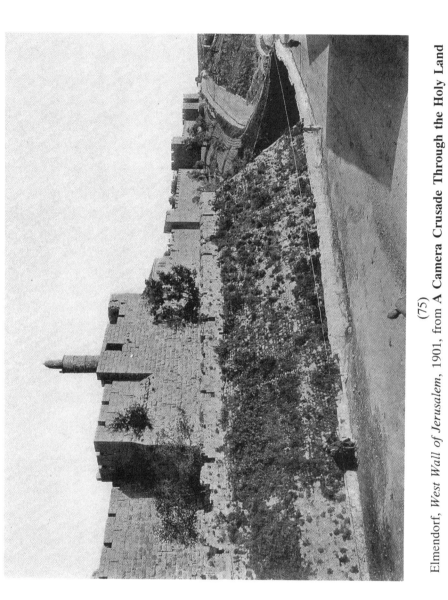

Elmendorf, *West Wall of Jerusalem*, 1901, from **A Camera Crusade Through the Holy Land**

(75)

Zangaki 1052

Zangaki, *Outside Jaffa Gate: the road leading to Bethlehem*, Mohammed B. Alwan Collection

(76)

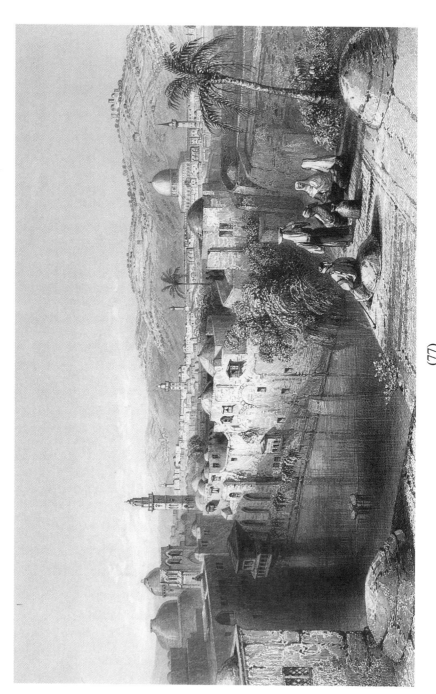

(77)

Bartlett, *Pool of Hezekiah*, 1842, private collection

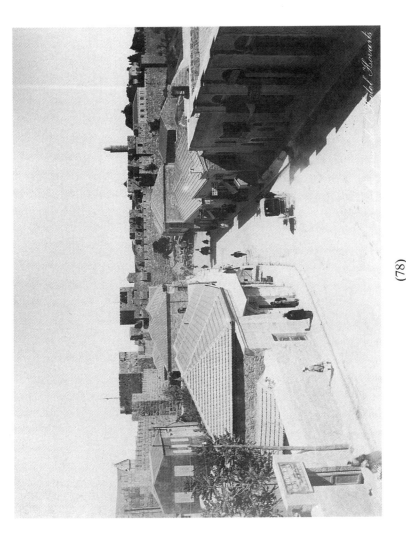

(78)

Zangaki, *Jaffa Road outside the wall of Jerusalem*, 1890s, private collection

The photographic studio of Krikorian—the first local to establish a photographic studio in the city—appears on the right.

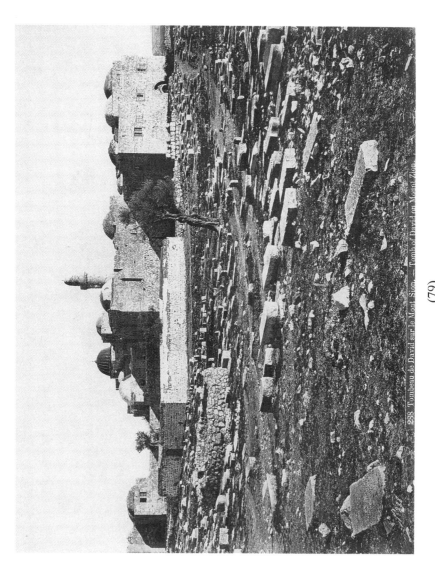

(79)

Bonfils, *Tomb of Davis on Mount Zion*, Mohammed B. Alwan Collection

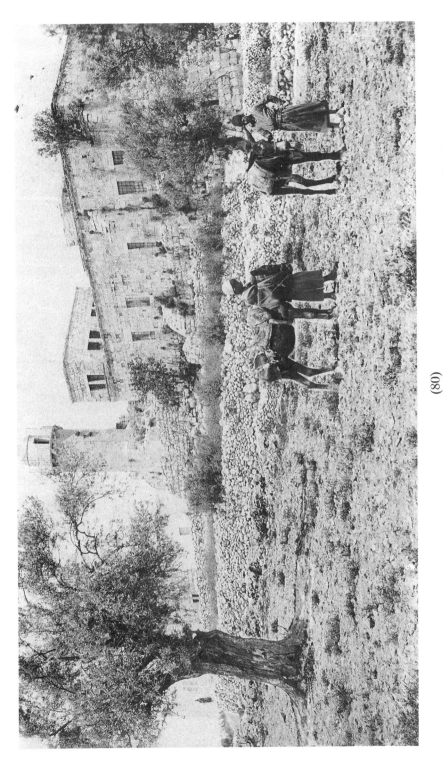

(80)

Zangaki, *Two boys with donkeys near Jerusalem*, 1890s, Mohammed B. Alwan Collection

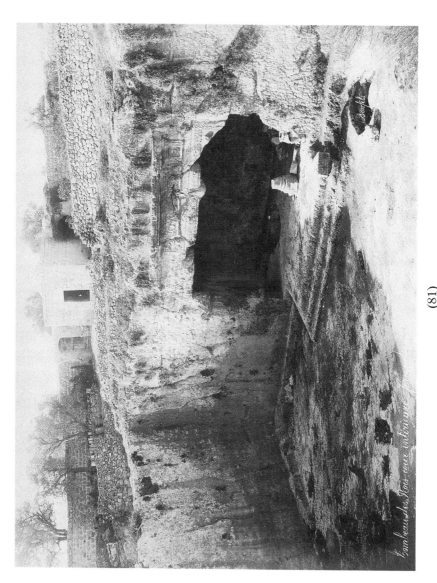

(81)

Bonfils, *Tombs of the Kings*, Mohammed B. Alwan Collection

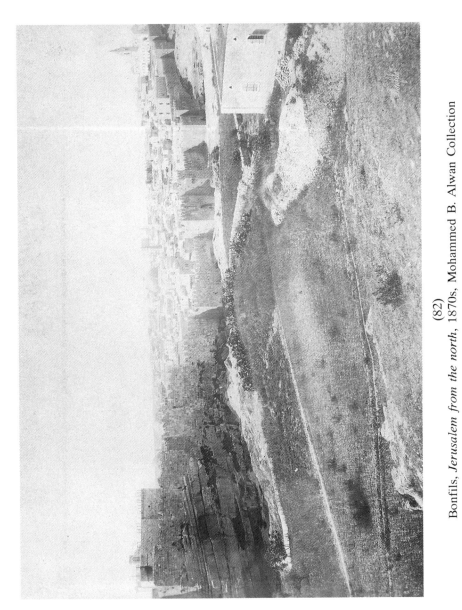

(82)

Bonfils, *Jerusalem from the north*, 1870s, Mohammed B. Alwan Collection

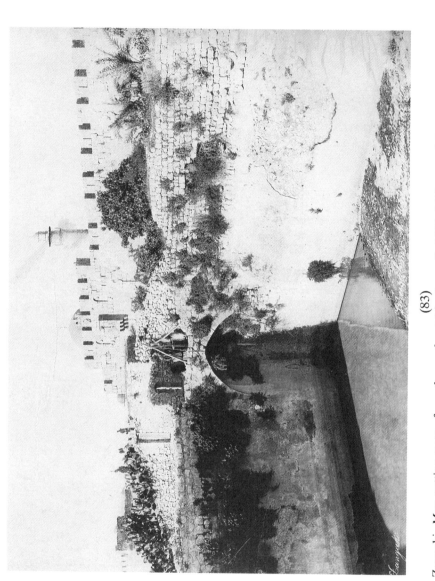

(83)

Zangaki, Men getting water from the pool outside the wall, 1890, Mohammed B. Alwan Collection

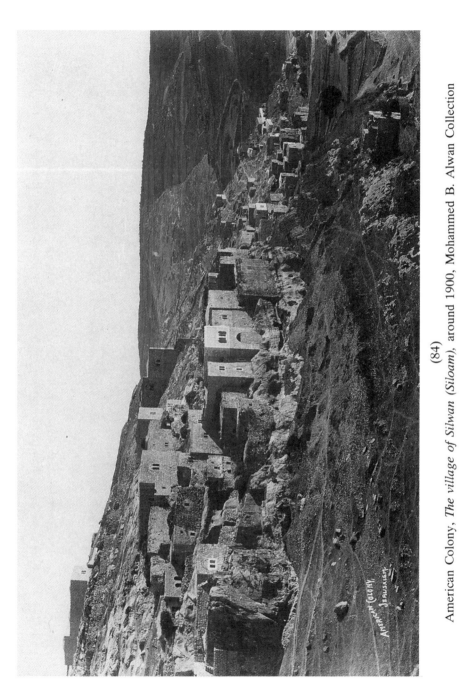

(84)

American Colony, *The village of Silwan (Siloam)*, around 1900, Mohammed B. Alwan Collection

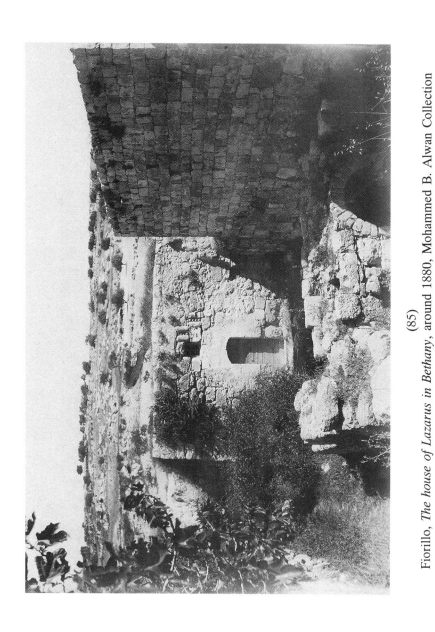

(85)

Fiorillo, *The house of Lazarus in Bethany*, around 1880, Mohammed B. Alwan Collection

There is no evidence to support Fiorillo's claim that this was the house of Lazarus. However, it is likely that this was an old abandoned house in the village of El-'Azariyeh.

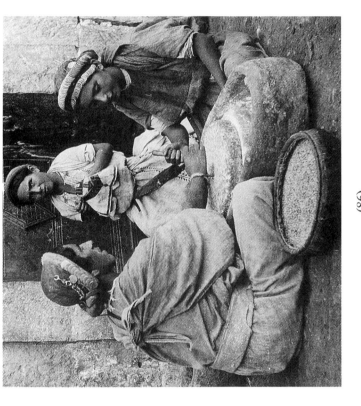

(86)

Keystone Stereoscope, *Native women grinding wheat, Palestine*, around 1900, private collection

On the back of this stereoscopic card the process of grinding wheat is described at length. Then the author seems to be making a point about the ethnic background of the people of Palestine. The following questions are offered for the reader to ponder: "The picture is interesting because it shows you the kind of people that live in Palestine. *Study their faces. Do they look like Indians? Observe the head–dress of the women. What is in the bowl beside the grinding mill?*"

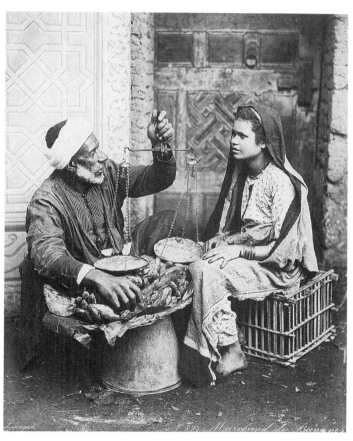

(87)
Zangaki, *Street vendor*, Mohammed B. Alwan Collection

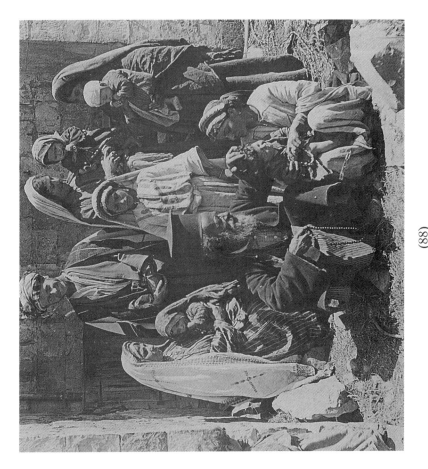

(88)

Underwood and Underwood Stereoscopes, *A Greek priest blessing the village children in Ramah*, 1900, from **The Travel Lessons on the Life of Jesus**, private collection

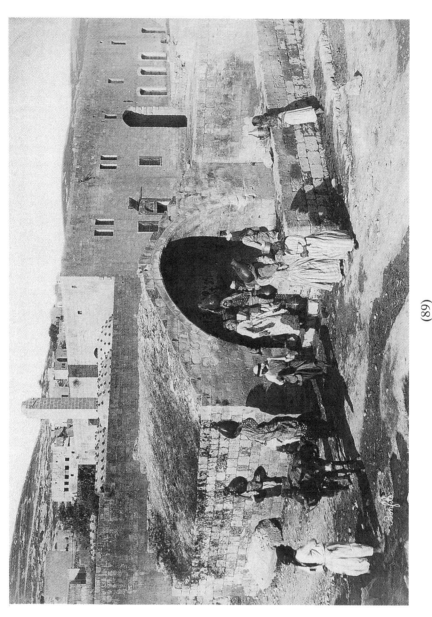

(89)

Bonfils, *The fountain of the Virgin in the center of Nazareth*, Mohammed B. Alwan Collection

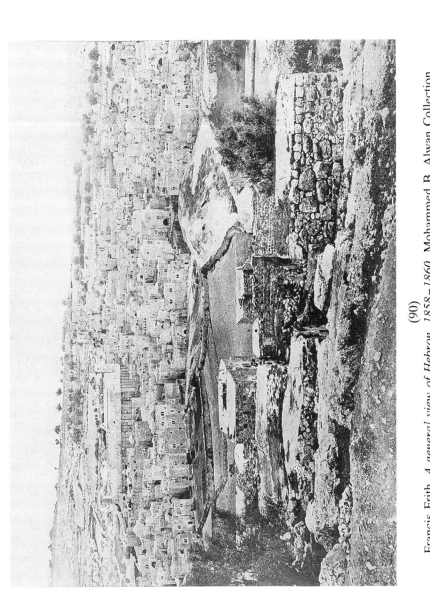

(90)

Francis Frith, *A general view of Hebron, 1858–1860*, Mohammed B. Alwan Collection
The large building on the right is al–Ibrahimi mosque, site of the Machpelah cave.

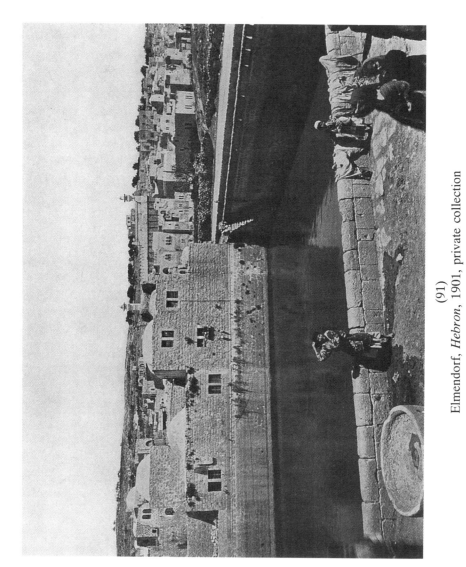

(91)

Elmendorf, *Hebron*, 1901, private collection

(92)

Bonfils, *Khan el–Hamar on the Road to Jericho*, Mohammed B. Alwan Collection

Khan el–Hamar is often identified as the site of the Good Samaritan episode. The claim is unfounded, however. The history of this site goes back to the 4th century when it was an important monastic center associated with St. Euthymius. In the 5th century this site seems to have been transformed into a church which was ruined by an earthquake around 660 AD.

(93)

Bonfils, *St. George Monastery* 1880s, Mohammed B. Alwan Collection

The Monastery of St. George of Koziba at Wadi al−Qilt' is west of Jericho. This Greek Orthodox monastery was first built by five hermits around AD 420. It was abandoned after the Persians destroyed it in AD 614 and restored in 1179 by Manuel I Comnenus. The last reconstruction of this monastery started in 1878, shortly before this photograph was taken.

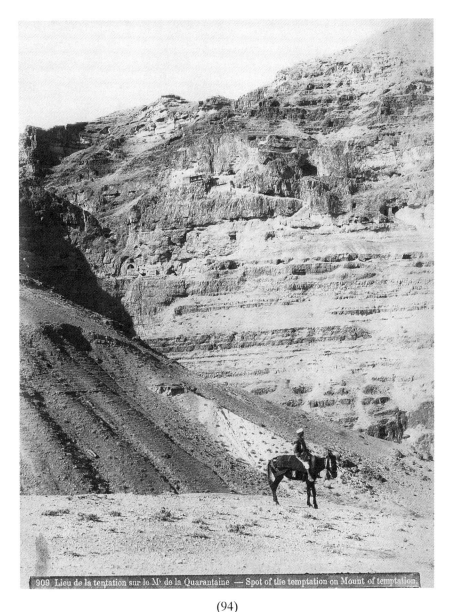

909 Lieu de la tentation sur le M^t de la Quarantaine — Spot of the temptation on Mount of temptation.

(94)

Bonfils, *A man on horseback in front of Jabal Quruntul (Mount Temptation) near Jericho,* 1880s, Mohammed B. Alwan Collection

This mountain has traditionally been associated with the Biblical first and third temptations of Christ. The monastery on this mountain was rebuilt starting in 1874.

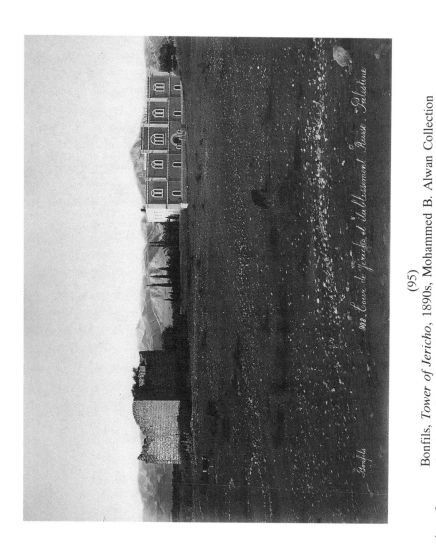

(95)

Bonfils, *Tower of Jericho*, 1890s, Mohammed B. Alwan Collection

The ruins of a crusader tower (known to European pilgrims as the House of Zaccheus) next to the Russian pilgrims' hospice.

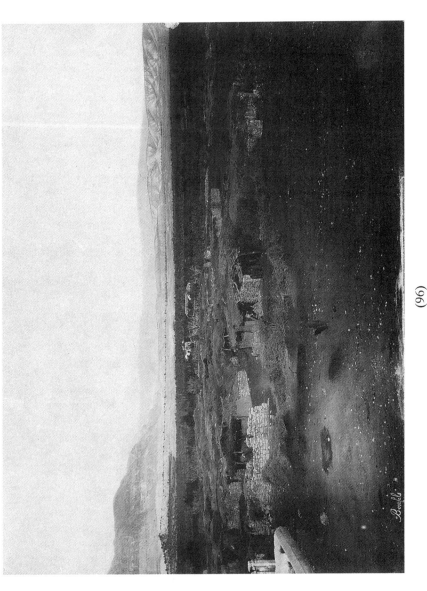

(96)

Bonfils, *A view of Jericho from the Crusader Tower*, 1890s, Mohammed B. Alwan Collection

(97)

Bonfils, *The Jordan River*, Mohammed B. Alwan Collection

(98)

Bonfils, *Resting on the banks of the Jordan*, 1880s, Mohammed B. Alwan Collection

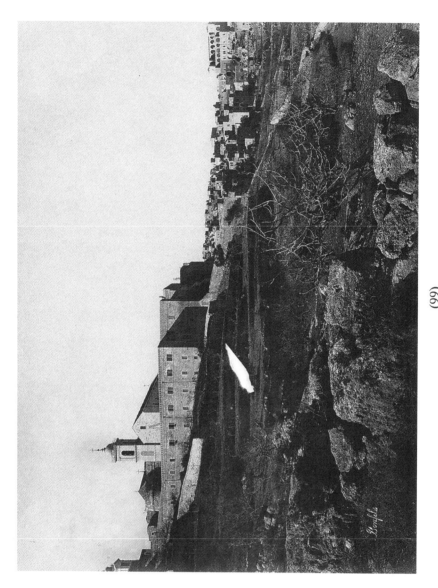

(99)

Bonfils, *A view of Bethlehem*, 1890s, Mohammed B. Alwan Collection

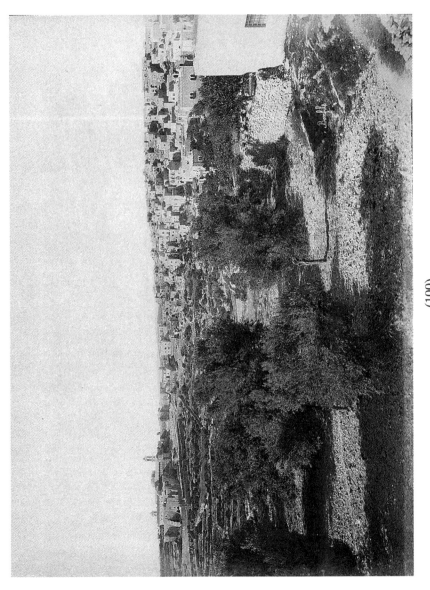

(100)

Bonfils, *General view of Bethlehem and Church of the Nativity*, Mohammed B. Alwan Collection

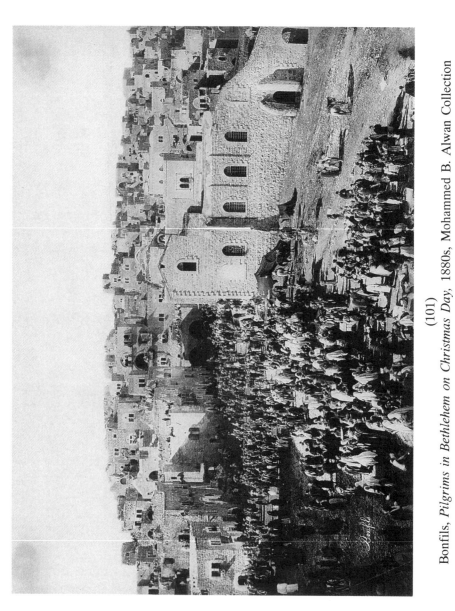

(101)

Bonfils, *Pilgrims in Bethlehem on Christmas Day*, 1880s, Mohammed B. Alwan Collection

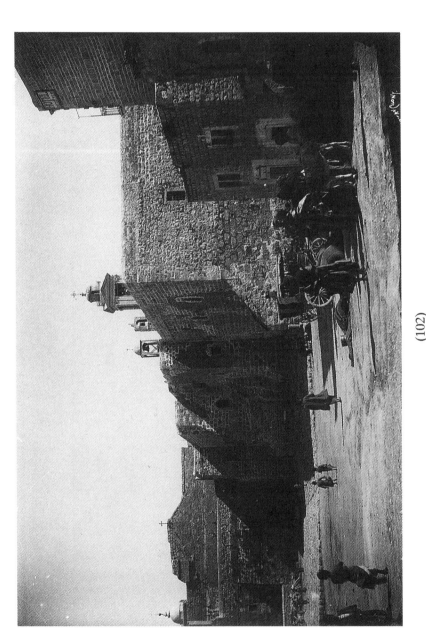

(102)

American Colony, *Manger Square and the Church of the Nativity*, around 1900,
Mohammed B. Alwan Collection

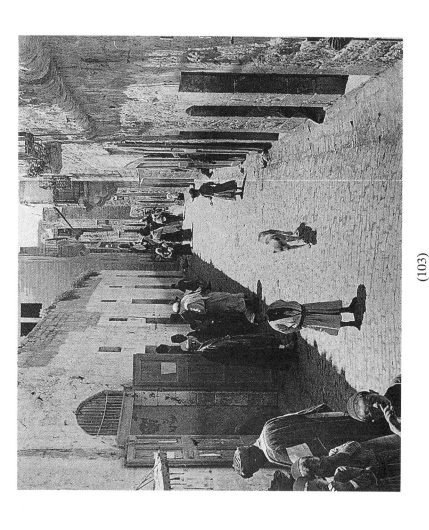

(103)

Underwood and Underwood Stereoscopes, *The main street of Bethlehem leading from the Church of the Nativity*, 1904, from **The Travel Lessons on the Life of Jesus**, private collection

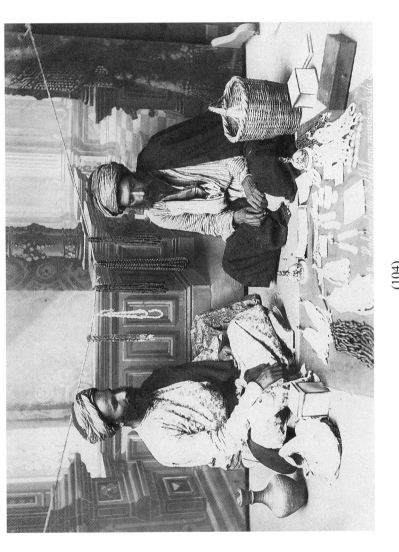

(104)

Bonfils, *Men selling beads in Bethlehem*, Mohammed B. Alwan Collection

Bonfils entitled this photograph "merchants of Bethlehem". It is questionable whether this photograph was taken in Bethlehem or in his studio in Beirut. It is clearly a staged photograph.

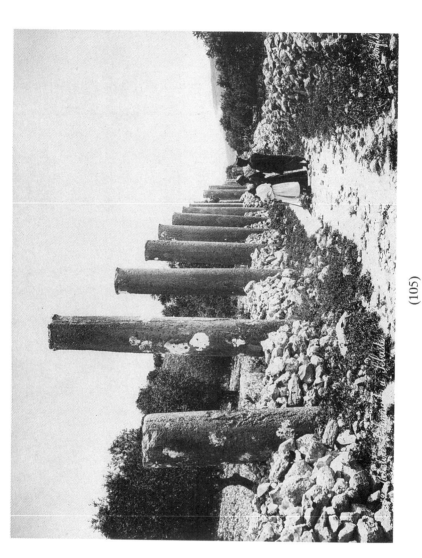

(105)

Bonfils, *Ancient ruins in Sabastiya; the site of ancient Samaria*, 1880s,
Mohammed B. Alwan Collection

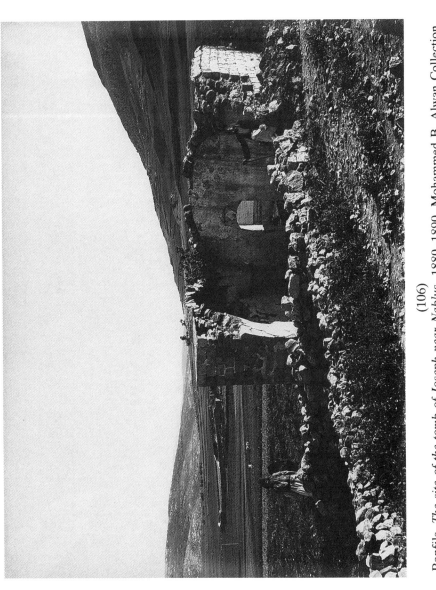

(106)

Bonfils, The site of the tomb of Joseph near Nablus, 1880–1890, Mohammed B. Alwan Collection

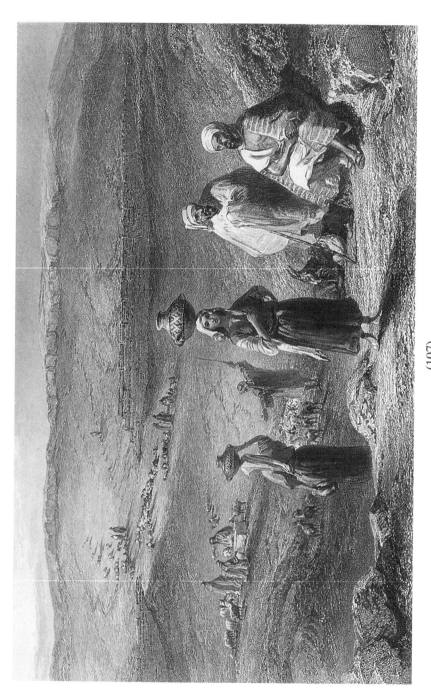

(107)

Bartlett, *Wells and remains of the pool at Bethel*, 1842, private collection

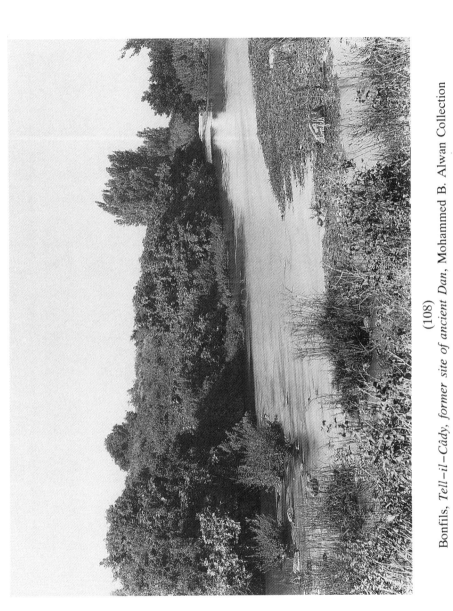

(108)

Bonfils, *Tell–il–Càdy, former site of ancient Dan*, Mohammed B. Alwan Collection

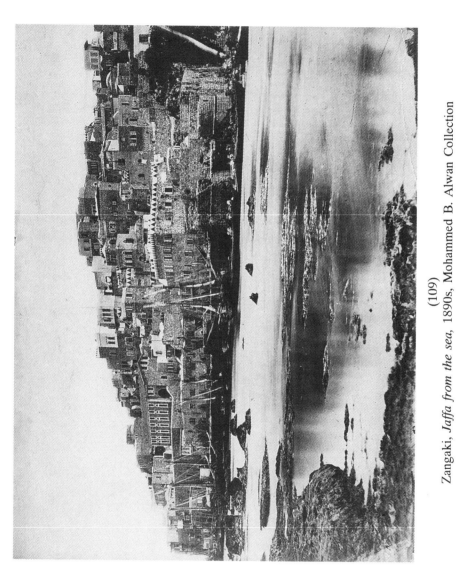

(109)

Zangaki, Jaffa from the sea, 1890s, Mohammed B. Alwan Collection

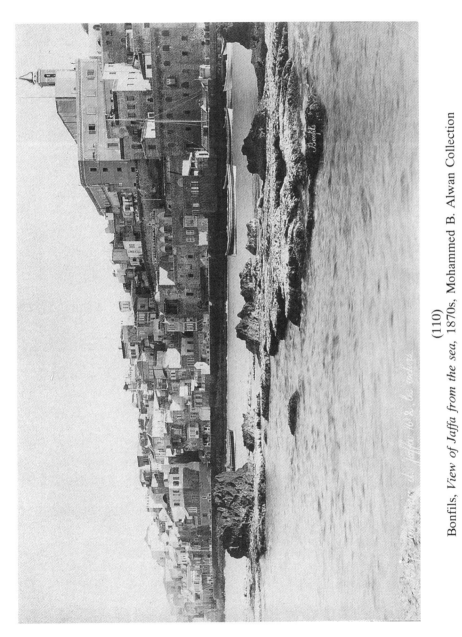

(110)

Bonfils, *View of Jaffa from the sea*, 1870s, Mohammed B. Alwan Collection

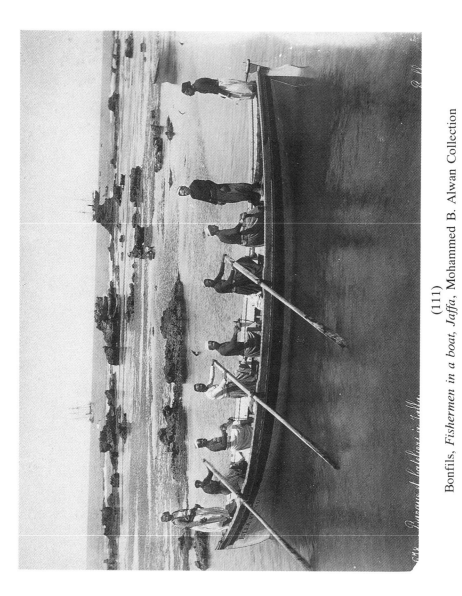

(111)

Bonfils, *Fishermen in a boat, Jaffa*, Mohammed B. Alwan Collection

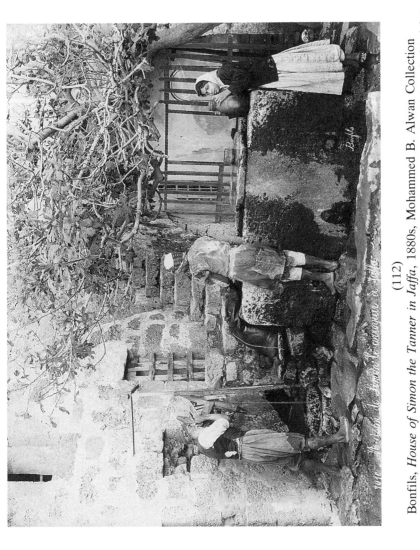

(112)

Bonfils, *House of Simon the Tanner in Jaffa*, 1880s, Mohammed B. Alwan Collection

According to the Bible, Peter had a vision here that showed him that pagans should be admitted into the church. However, the identification of this site as the house of Simon the Tanner is far–fetched.

APPENDIX 1

NINETEENTH-CENTURY CHRONOLOGY OF EVENTS

1799: Napoleon's troops cross the Sinai desert and occupy the coast of Palestine from El-Arish up to Haifa.

1807: Mustafa IV becomes Sultan of the Ottoman Empire.

1808: Mahmud II becomes Sultan of the Ottoman Empire; a fire inside the Church of the Holy Sepulcher was believed to have been started by the Armenians over issues of property of the church.

1819: The Greek Orthodox begin to repair the Church of the Holy Sepulcher.

1821: Following the revolt of the Greek Islands, the Orthodox Christian Community of Jerusalem was faced with harsh measures; the Sultan orders the *wally* to search the pilgrims and to guard against rumors spread by Christians.

1831: Egyptian forces led by Ibrahim Pasha conquer Palestine.

1834: A revolt takes place in Palestine and Transjordan against the rule and the reforms of Ibrahim Pasha.

1834: Ibrahim Pasha attends the Easter celebration at the Holy Sepulcher where many worshipers suffocated inside or were killed or injured in the ensuing chaos. Following this incident calls for a peaceful crusade to establish a European Christian enclave in the Holy Land start to emerge in Europe.

1836: The British Jewish philanthropist Sir Moses Montefiore visits Jerusalem for the first time.

1838: The American archeologist Edward Robinson arrives in Jerusalem for the first time.

1839: Abdumecid I becomes sultan of the Ottoman Empire; William Turner Young arrives in Jerusalem to become the first British vice consul.

1840: Palestine returns to Ottoman rule and the Egyptian forces withdraw.

1841: The Anglo-Prussian Protestant Bishopric is established in Jerusalem.

1842: The first Prussian Consulate is established in Jerusalem.

1842: Bishop Michael Solomon arrives in Jerusalem to assume the position of the first Protestant bishop of the city.

1843: The Sardinians and the French establish their consulates in Jerusalem.

1843: The London Jews Society establishes a hospital offering free medicine for Jews on the borders of the Jewish Quarter.

1845: The Greek-Orthodox Patriarch moves his operation from Constantinople to Jerusalem.

1847: The Austrian consulate is established; the Latin Patriarchate of Jerusalem is re-established.

1848: The Sisters of St. Joseph of the Apparation establish a presence in Jerusalem becoming the first Catholic female order in the city.

1849: The Christian sect known as Melkite Catholic (or Greek Catholic) holds its synod in Jerusalem.

1854: Yakoob Pasha becomes Governor of the City, replacing Hafiz Ahmed Pasha; the first Spanish Consulate is established.

1854-56: European rivalry over protection of Christian minorities in the Ottoman Empire results in the Crimean War. The issue of the property of the holy sites of Jerusalem becomes a subject for negotiation between the European powers.

1856: The American Consulate is established.

1857: The Russian Consulate is established.

1860: The first wave of Jewish settlement is built outside of the walls of the city.

1861: Abdulaziz becomes the Sultan of the Ottoman Empire.

1862: The Prince of Wales Albert Edward, who was later to become King Edward VII, visits Palestine.

1863: The first municipal council of Jerusalem (*baladiyyat al-quds*) is established.

1865: Captain Charles Wilson of the British Royal Engineers arrives in Palestine to study the hydrology of Jerusalem; a group of British scholars, churchmen and public figures gather in London to establish the Palestine Exploration Fund.

1867: Charles Warren arrives in Jerusalem on an archeological expedition for the Palestine Exploration Fund.

1871: German Protestants from Württemberg build the German Colony, south of Jerusalem.

1876: A palace revolution makes Murad V the new Sultan of the Ottoman Empire. However, he is soon deposed on the grounds of insanity and is replaced by Abdulhamid II.

1877-8: Yusuf al-Khalidi becomes the first Jerusalem delegate to the short-lived Ottoman parliament.

1878: The new Christian sect of Greek Catholics establishes a high school and a dormitory for boys on the Via Dolorosa, near the Church of St. Anne.

1882: Arab Christians establish the Orthodox Palestine Society; the *Société deu Chemin de Fer Ottoman de Jaffa a Jérusalem et prolongement* completes the construction of the rail line between the two cities; Prince George, later to be known as King George V, visits Jerusalem.

1890: The *Ecole Biblique*, the Dominicans' Scientific Institute in Jerusalem, is founded.

1898: The German Kaiser visits Jerusalem; Theodor Herzl, the founder of Zionism, visits Jerusalem.

APPENDIX 2

INVENTION AND DEVELOPMENT OF PHOTOGRAPHY IN THE NINETEENTH-CENTURY

Although the first photographic print appeared only around 1825, the photographic process itself had been developing slowly for hundreds of years. The prehistory of chemical photography, it can be argued, goes back to the age of antiquity. For it had long been known that exposing objects such as human skin to sun light would produce more or less dark tanning images, depending on the amount of light and the time of exposure. The prehistory of the optical part of photography, on the other hand, can be traced back to at least the tenth century, when Hassan of Basra used the *Camera Obscura* (referred to in Arabic as *a room with a sunlit view*). Over the next few centuries, scientists and artists continued to use it to produce images and reflections of objects. In 1685, the German Johann Zahn developed the *Reflex Box Obscura*, a *Camera Obscura* that used mirrors to reflect the image on a glass surface. This reflex box enabled the artist to draw his subjects simply by placing a paper on the surface and following the lines of the images. This method continued to be used to produce illustrations until the second half of the nineteenth century. In 1806, the same principle was used by William Hyde, to produce a more mobile form of the *Obscura*, the *Camera Lucida*. It consisted of three telescoping brass tubes, a table clamp and an adjustable peep sight with a spectacle lens. The *Camera Lucida* made it easier for the artist to carry his equipment from one location to another in order to draw the different objects. With the use of both the *Camera Obscura* and the *Camera Lucida*, images of distant people and places were made available. Following the invention of the printing process, they became accessible to a wider public, for printers used the etched engravings to make plates that were inked and mass produced.

In contrast to the slow paced development of the Camera, chemical photography was a process which developed in a rather fast way since the early decades of the nineteenth century. Although the invention of chemical photography is commonly associated with the name of Louis-Jacques Mande Daguerre, it is questionable that we could attribute the entire invention of the photographic process to one particular individual. Nonetheless, Daguerre — who developed a process of his own known as daguerreotype photography — played a

very important role in popularizing photography. Daguerreotypes were among the first fixed images to be produced. The image was generally printed on a copper plate coated with silver and then sensitized with the fumes of iodine.[1] The plates were then developed and fixed with mercury fumes. The images produced according to this method were *positive images* and it was not possible to make copies of them, the way we do with the use of negative images nowadays. Producing a daguerreotype was an expensive process that required the use of bulky equipment and specially manufactured silvered copper plates. It also required the careful cooperation of the subject of the photograph. Initially, the exposure process was very long and often required the use of special equipment to help the person being photographed remain still. In the same year that Daguerre announced his invention, the following commentary appeared in the satirical French journal *Le Charvir*:

> You want to make a portrait of your wife. You fix her head in a temporary iron collar to get the indispensable immobility.... You point the lens of the camera at her face and then when you take the portrait it doesn't represent your wife; it is her parrot, or watering pot or worse.[2]

The invention that carried Daguerre's name could not have been possible without the previous work of, and the collaboration he had with, Joseph Nicéphore Niépce who had already taken the first known photograph twelve years before the announcement of the invention of Daguerre. Niépce, also French, produced the first fixed *Camera Obscura* image on a plate coated with bitumen of Judea and washed with oil. This process, known as heliography, required an exposure time of several hours. Niépce and Daguerre became partners and worked together in the development of the photographic process. Unfortunately, Niépce died around 1833 before he saw the extent to which photography would change the world through its influence on people's imagination, memory and knowledge.

While Daguerre's invention produced sharp images of the objects filmed, it did not allow for the production of duplicates. The daguerreotype was a unique picture that had to be handled with extra care. It had to be protected from the viewer's hands by a complex process of coating and then it had to be placed in a glass frame. The positive image that it produced was in reverse, just as the images produced by mirrors.

While daguerreotype photography was the first photographic process to be announced to the world, it was not the only one developed during that time. The process that is, perhaps, most relevant to photography as we know it was also announced in 1839. The English scientist William Henry Fox Talbot developed independently a technique which he thought was identical to that of Daguerre.[3] In the year 1835, Talbot was able to produce an image on paper that was drenched in a salt solution mixed with silver nitrate. The image he produced after exposing the paper to light was what we call today a negative image. Talbot was able to fix this negative image (i.e., make it permanent) by using potassium iodide. From the negative, Talbot was able to produce as many positive pictures as he wished. This process that he called photogenic drawing or calotype (meaning beautiful picture in Greek) was not as perfect as he thought it to be at first. In contrast to the daguerreotypes, the images in the photogenic drawings were less permanent and sharp. It was not until 1841 that Talbot realized that a much shorter exposure to light would produce a better negative image on the paper. This negative image could not be seen until it was developed in a mixed solution of silver nitrate and potassium bromide and fixed with the use of a hot solution called hypo.

However, Talbot's invention was far from producing an image as clear as that of the daguerreotype. The blur effect posed a problem, especially when the object of the *photogenic drawing* had more than two dimensions. Talbot's use of paper as the base for his negatives was problematic, for the texture of the paper affected the quality of the positive copy. The major problem, however, was that both types of photography — Daguerreotypes and photogenic drawings — required long exposure times, a fact that limited their practical use to carefully planned studio portraits.

The search for a sharp image that could be easily reproduced led scientist to explore the idea of using a combination of both processes at once. In 1847, Claude Félix Niépce (Joseph Nicéphore's brother) managed to produce a negative image on a glass surface using egg whites, or albumen.[4] In terms of the clarity of the image, the resulting negative was far superior to that produced on a paper negative. While this process did not provide a solution for the problem of reducing exposure times, the clarity and reproducibility of the picture made it popular among photographers of still images. With this process, photographers who traveled to far away lands were able to produce sharp lasting images of sites of particular

interest to the European viewers, such as those of the Holy Land or Egypt. As for the problem of long exposure time, the solution had to wait a few more years.

In 1851, the English Frederick Scott Archer used successfully a combination of alcohol, ether and guncotton to produce a fluid known as collodion. By using collodion on a glass plate and developing the negative immediately after exposure (before the emulsion on the plate dried up), he managed to cut down the exposure time drastically (from a few seconds to a couple of minutes, depending on certain conditions).[5] Unfortunately, this meant that the photographer needed to have his darkroom on site for the plate preparation and development processes. This problem was solved in 1855 with the introduction of dry plate photography (or dry collodion) in which the collodion was covered with gelatin or albumen. However, the image produced from through this process was not as sharp as that produced through the wet process. The collodion process remained popular and widely used until the introduction of the gelatin dry plates in the 1870's.

The gelatin dry plate was first mentioned in a letter by Richard Leach Maddox to the British journal of photography in 1871. Maddox offered his ideas to the reader because he himself did not have the time to explore them.[6] Although it took a few years to develop this process fully, the results it produced made it more popular than its predecessor, the wet collodion plate. This process that used gelatin machine- coated plates eventually led to the introduction of the gelatin silver paper, which is still in use today. The dry gelatin plate process was further developed by George Eastman who established a company that specialized in producing gelatin plates in the State of New York in 1888. This company, which later became known as Kodak, was the first to replace the paper used in the dry plates by a transparent nitrocellulose film in 1891.

NOTES

1. James Buerger, *French Daguerreotypes* (Chicago: University of Chicago Press, 1989), 4.

2. Beaumont Newhall, *The History of Photography from 1839 to the Present* (New York: The Museum of Modern Art, 1982), 28.

3. *Ibid.*, 19.

4. Alma Davenport, *The History of Photography: An Overview* (Boston and London: Focal Press, 1991), 18.

5. Brian Coe and Mark Haworth-Booth, *A Guide to Early Photographic Process* (Victoria & Albert Museum, 1983), 18.

6. *Ibid.*, 22.

APPENDIX 3

1826: Joseph Nicéphore Niépce produces the first photographic image in a process that he calls Heliography.

1833: William Henry Fox Talbot conceives of the idea of "photogenic drawings."

1837: Earliest known daguerreotype by Louis Jacques Mande Daguerre.

1838: The stereoscope is invented.

1839: Daguerre's process is published; Talbot exhibits and describes photogenic drawing; the first daguerreotypes made in Egypt and Jerusalem by Horace Vernet and Frédéric Goupil-Fesquet who arrive in Palestine in December of 1839 as part of a larger project to collect images of different parts of the world designed by the French Lerebours.

1840-44: Goupil-Fesquet's daguerreotypes of Jerusalem appear in *Les Excursions daguerriennes* published in France.

1841: Talbot patents the calotype.

1842: De Prangey's takes daguerreotypes of Italy, Egypt, Palestine, Syria, and Greece.

1844: George Skene Keith takes daguerreotypes of Jerusalem.

1847: Albumen plates are invented by Niépce de Saint-Victor.

1849-50: French photographer Maxime Du Camp takes several calotype photographs of Jerusalem; the French Louis Desire Blanquart-Evrard announces his invention of the albumen printing paper on May 27; Teynard calotypes of Egypt and Palestine; Irish photographer John Shaw Smith photographs Jerusalem; Robertson and F. Beato photograph Constantinople and Egypt.

1851: Frederick Archer develops the wet collodion process; the First International Photographic Exhibition is held in London.

1852: Du Camp publishes seven photographs of Jerusalem in his *Egypte, Nubie, Palestine et Syrie*.

1853: The Scottish missionary James Graham settles in Jerusalem for three years during which he photographs the city.

1854: The French photographer Auguste Salzmann and the American missionary James Turner Barclay photograph Jerusalem.

1855: Fenton's and Robertson Crimean's photographs are published as engravings.

1856: Herr Rabach opens a studio and trains Abdullah Brothers (Kevork and Wichen) in Istanbul; Francis Frith's first journey to Egypt; Mendel John Diness practices photography in Jerusalem.

1857: Robertson and Beato photograph Palestine on way to India; Francis Frith visits Palestine and Syria (probably with F.M. Good).

1858: Herr Rabach returns to Germany leaving studio to Abdullah Brothers;*L'Egypte et Nubie,* published by Teynard; W. Hammerschmidt photographs Egypt (dry plate collodion).

1859: Yessayi Garabedian establishes a photography workshop in St. James Armenian Convent; Photographer Louis de Clercq accompanied Emmanuel Guillaume Rey French archeological expedition to the Near East after which he published five volume series of albums entitled *Voyage en Orient* containing 177 photographs of Syria, Palestine and Egypt.

1860: Scottish photographer John Cramb photographs Palestine.

1861: Cramb publishes a series of articles in *The British Journal of Photography* entitled "Palestine in 1860, or A Photographer's Journal of a Visit to the Holy Land."

1862: Francis Bedford photographs Prince of Wales's Near East tour; Hammerschmidt publishes *Souvenirs d'Egypte*; Antonio Beato opens a studio in Luxor.

1863: British photographer H.T. Bowman accompanies H.B. Tristram, canon of Durham, on a journey to Palestine. Both men collaborate on an illustrated book entitled *The Land Of Israel.*

1865: *Ordnance Survey of Jerusalem* published by Captain Charles Wilson and includes photographs by James McDonald; Piazzi Smyth photographs interior of Great Pyramid; the Palestine Exploration Fund is founded in London.

1866: Lallemand, *La Syrie: Costumes, Voyages, Paysages*; the photographer Henry Philips accompanies Charles Wilson on his archeological survey of Palestine.

1867: Félex Bonfils settles in Beirut.

1868: Earliest Bonfils photographs of Jerusalem; J. Pascal Sebah opens a studio in Istanbul.

1868-78: F.M. Good selling sets of "Good's Eastern Views."

1870: Foundation of the American Palestine Exploration Society; the Italian photographer Fiorillo settles in Alexandria and photographs the region.

1871: Gelatin emulsion invented by Maddox; George Smith publishes Thompson's Assyrian photographs.

1872: French photographer Tancréde R. Dumas publishes a photographic catalogue that includes his photographs of Palestine.

1873: American photographer Benjamin West Kilburn markets his stereoscopes of Near East; orthochromatic emulsion developed by Vogel.

1874: Publication of Duc de Luynes's Jordan photographs by Vignes.

1875: American Palestine Exploration Society commissions Tancréde R. Dumas to photograph Palestine.

1877: Gelatin dry plates introduced.

1880: The first photographic halftone image appears in New York's *Daily Graphic*; French photographer Jules Ruffier settles in Jerusalem.

1885: Garabed Krikorian opens a photographic establish-
 ment in Jerusalem; Snouck Hurgronje photographs
 pilgrims in Jeddah and trains physician al-Sayyid
 'Abd al-Ghaffar to make photographs of Mecca.

1886: Max van Berchem begins his photographic collec-
 tions in Egypt.

1888: George Eastman introduces gelatin plates negative
 and his Kodak camera.

1890: Khalil Raad becomes the first Christian Arab
 photographer working in Jerusalem; S. Hakim
 photographs Damascus Mosque after fire.

1891: Eastman introduces the transparent nitrocellulose
 film; the Russian photographer B. Warshawski
 photographs new Jewish settlements in Palestine.

1892: Daoud Sabounji becomes the first local Arab pho-
 tographer in Jaffa.

1893: Sultan Abdul Hamid presents numerous albums to
 US National Library (including photographs by
 Abdullah Brothers and Bonfils).

1898: American Colony Photography Department estab-
 lished in Jerusalem.

1901: American photographer Dwight Elmendorf pho-
 tographs Palestine.

1925: Leica and Ermanox cameras introduce 35 mm
 photography.

,